GUILDFORD

THROUGH TIME

David Rose
& Bernard Parke

AMBERLEY PUBLISHING

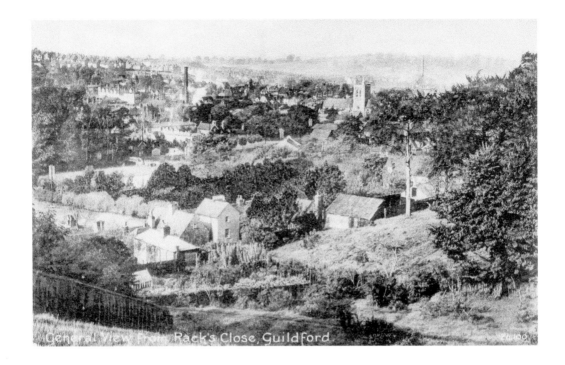

General View from Rack's Close, Guildford.

First published 2009

Amberley Publishing Plc
Cirencester Road, Chalford,
Stroud, Gloucestershire, GL6 8PE

www.amberley-books.com

Copyright © David Rose & Bernard Parke, 2009

The right of David Rose & Bernard Parke to be
identified as the Authors of this work has been
asserted in accordance with the Copyrights, Designs
and Patents Act 1988.

ISBN 978 1 84868 679 3

British Library Cataloguing in Publication Data.
A catalogue record for this book is available from
the British Library.

Typeset in 9.5pt on 12pt Celeste.
Typesetting by Amberley Publishing.
Printed in the UK.

Introduction

What would all those people who knew Guildford in the early 1900s say if they could see the town today? How much of it would they recognise straight away? What aspects would they find completely bewildering, as certain parts have changed beyond recognition?

Over the past 100 years Guildford has grown considerably, from a medium-sized market town to what is now a regional centre of the south-east of England.

If a Guildfordian of the Edwardian era could walk the same streets today he would obviously recognise the Guildhall and its famous clock. He'd find the attractive Castle Grounds very much unaltered. A stroll along the River Wey to St Catherine's and the meadows beside Shalford Park would be mostly familiar. Buildings such as the Royal Grammar School and St Mary's, St Nicolas' and Holy Trinity churches would be useful landmarks to indicate where he was.

Of course, there are many other buildings still standing that would look the same, but he'd probably be amazed at their use today. For example, the fire station in North Street is now a public lavatory and what was the Bull's Head pub no longer serves up beer but is currently a shoe shop.

If he went to the railway station he wouldn't recognise it at all. He'd lose his bearings in North Street as some fine buildings that once stood on the north side, including the post office and the Borough Halls, have all long gone.

The Friary Brewery has been replaced by the Friary Shopping Centre and if he walked along Onslow Street he wouldn't know where he was. In his day he'd have known the cattle market in Woodbridge Road well. Would he believe that on that site now are the police station and the law courts?

Guildford Through Time reflects the changing scenes of Surrey's county town. It is the first local history title about the town that uses colour reproduction of its pictures throughout.

Not all the old photos in this book date from the halcyon years of the picture postcard, that lasted from the 1900s to about the 1930s. There are a number of photos taken around the 1950s and '60s when much development was taking place that changed the landscape and skyline of Guildford town centre forever.

In many cases, when taking the 'today' photo, the authors have lined up the view as near as possible to the one in the 'old' photo. But, quite deliberately, this has not been the case with all of them. In some instances it was felt necessary to 'step back a bit' so to speak, to take in a slightly wider view of the scene today so as to include other points of interest.

We hope you enjoy this 'tour' of the town; see how many changes you can spot.

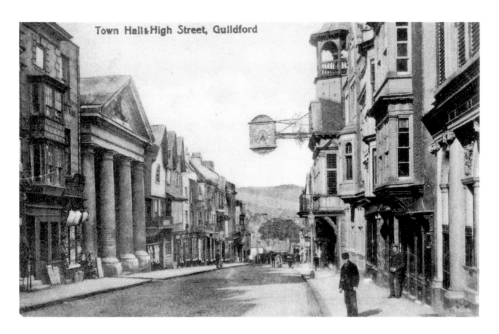

Town Hall & High Street, Guildford

The Guildhall Clock

The symbol of Guildford is the Guildhall clock that has stood over the High Street since 1683. The clock mechanism that is actually inside the building is much older and is attributed to a clock maker called John Aylward. In the older picture the clock is seen with replacement glass dials that were illuminated by gas lights. These did not last long and the original dials were put back in 1898.

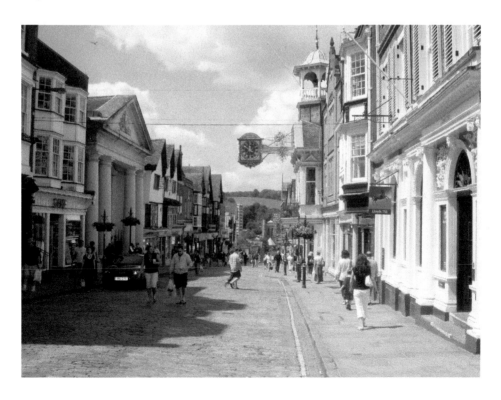

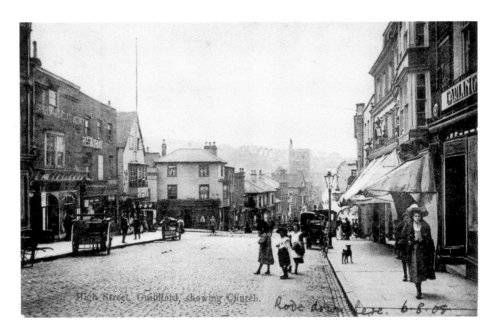

Guildford High Street

Blinds have been pulled out on some of the shop fronts, suggesting it was a sunny day when this Edwardian photograph was taken. The shop fronts themselves had heavy wooden shutters, and removing them at the start of the day's trading and replacing them in the evening was often a job for junior members of staff. Today Waterstone's bookshop occupies the site of a once well-known Guildford ironmonger — Carling, Gill & Carling.

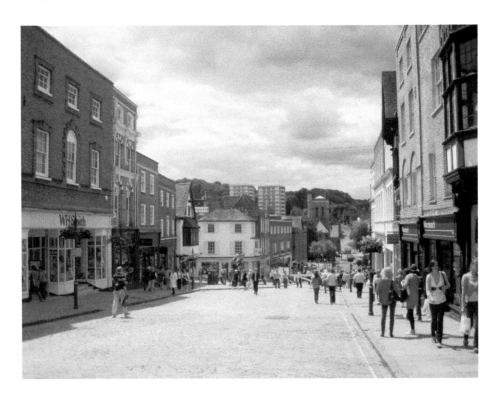

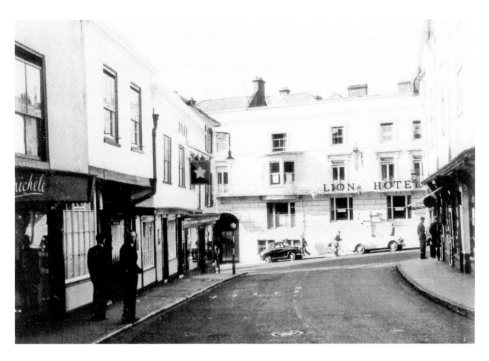

The Lion Hotel

The Lion Hotel has been gone for over fifty years, replaced by F. W. Woolworth in 1958. That made way for the White Lion Walk Shopping Centre that opened in 1986.

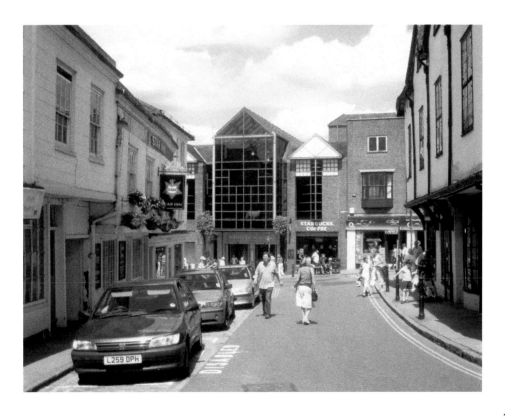

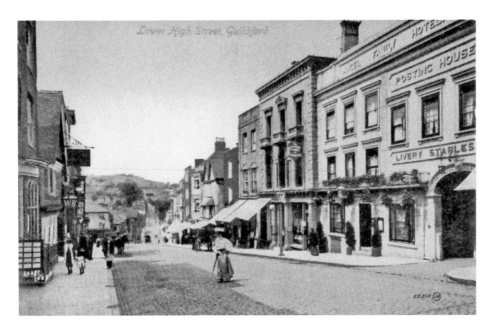

The Angel Hotel

Even buildings like the Angel Hotel have changed down the years. Note the words 'ANGEL FAMILY HOTEL' near the roofline on the photo from the early 1900s. The window frames are also different today. There appears to have been an inn on this site since at least the sixteenth century, and there are a number of ghost stories attached to the Angel!

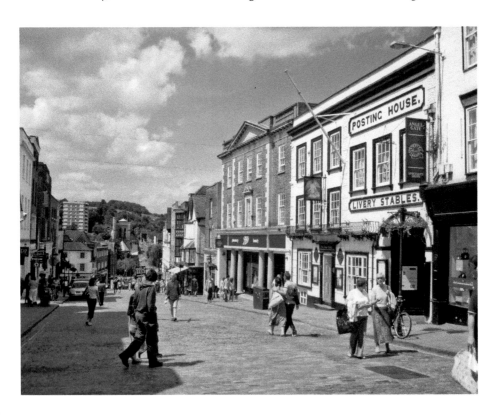

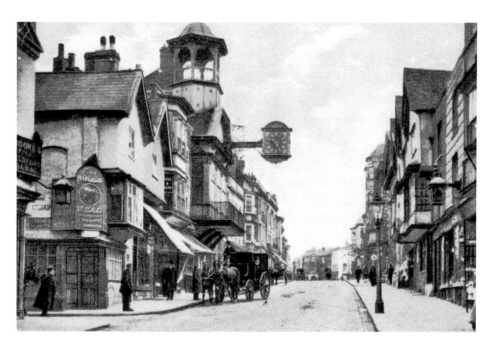

The Bull's Head Pub

A rather smart horse-drawn carriage is in the older view and several gas lamps can be seen. A lamp on the right hangs above what was then W. Taverner's chemists shop. The shop that today occupies the corner of the High Street and Market Street was once the Bull's Head public house. It was a sad day when this pub closed for good in 1988.

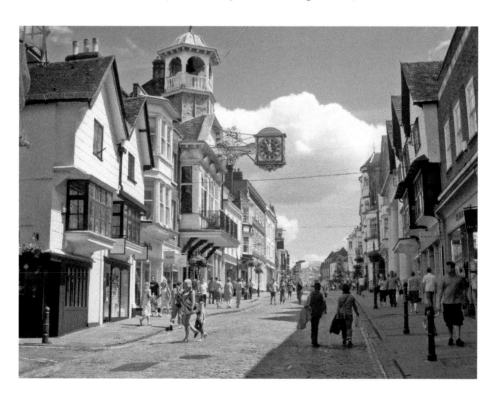

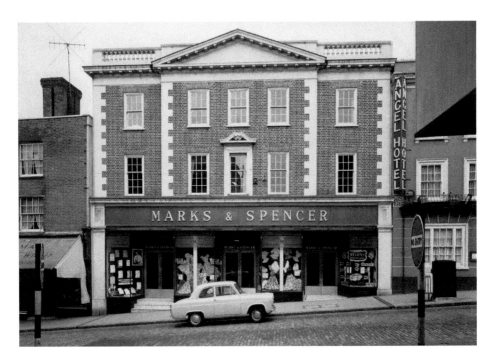

Marks & Spencer Then

Marks & Spencer once occupied this building built in the Georgian style. In the early 1960s M&S moved further down the High Street into premises that were once W. E. White & Sons' department store.

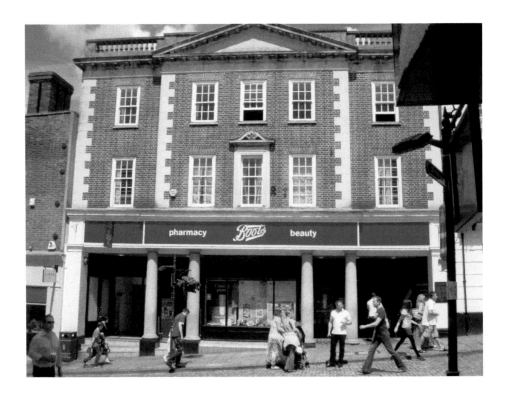

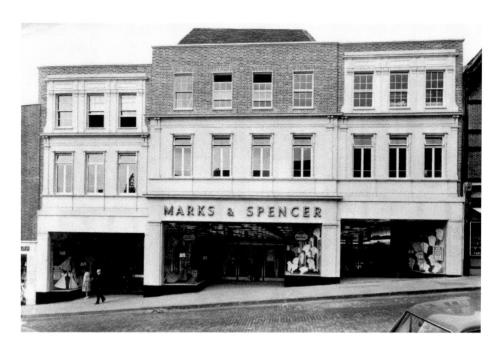

Marks & Spencer Now and Then

M&S paid a record £70,000 for the former W. E. White's site. The building's frontage has hardly changed over the past forty-plus years, but today there is a good deal more street furniture. Notice the addition of the bollards, a litter bin and the post supporting two hanging flower baskets.

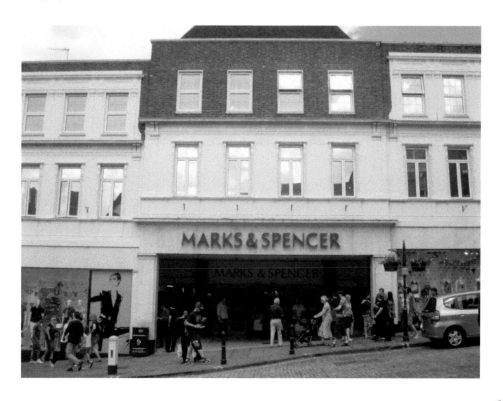

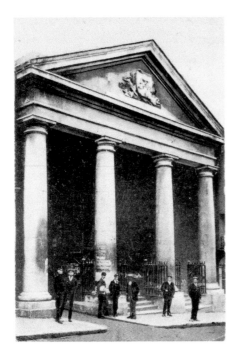

Tunsgate Arch

It was once said that Tunsgate was a gateway to nowhere! It was built in 1818 as a corn exchange at a time when Guildford's market was in the High Street. The main difference between these two views is the position of two of the stone pillars. They were moved in the 1930s at which time Tunsgate was opened up and made into an arch to allow road traffic to pass through.

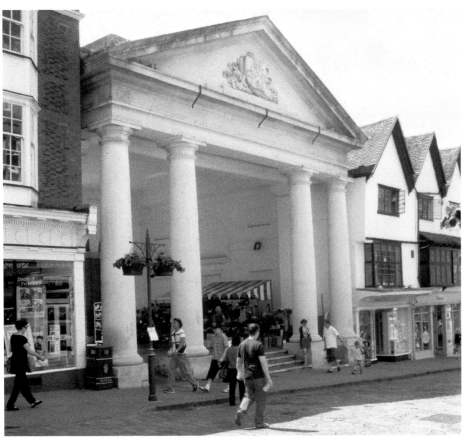

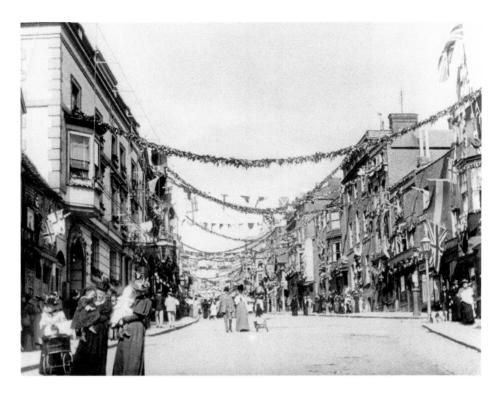

Lower High Street

The older view dates back to 1897 when the town was celebrating the Diamond Jubilee of Queen Victoria. Bunting and flags can be seen strung from building to building across the street. Throughout the twentieth century the town was decorated in a similar fashion to mark coronations and jubilees. Today, much of the pavement has been widened at the point where the High Street becomes pedestrianised.

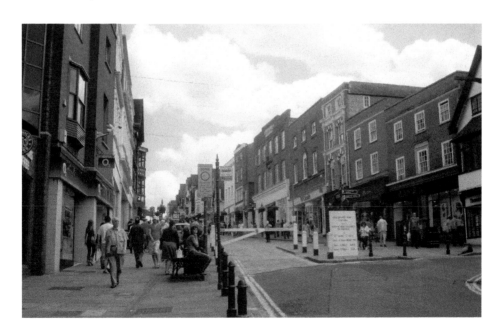

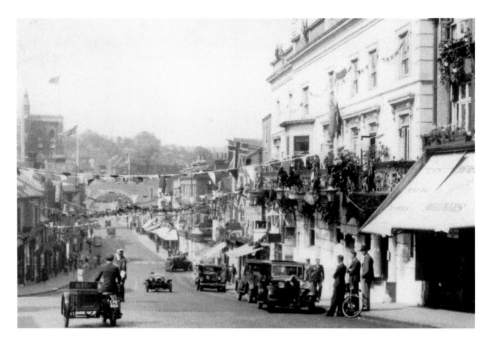

George V's Silver Jubilee

More flags and bunting, this time to mark George V's Silver Jubilee in 1935. There are some grand vehicles to interest any vintage car enthusiast. Compared with today's view, many of the buildings have gone, especially on the left-hand side below the junction of High Street and Quarry Street.

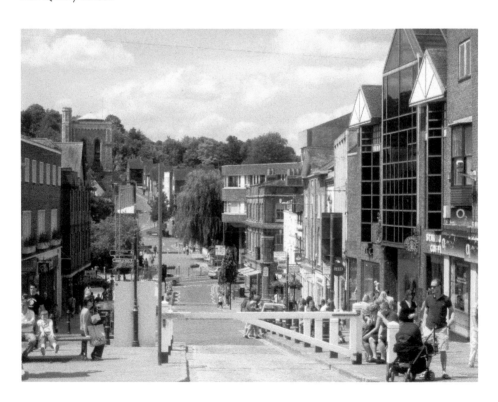

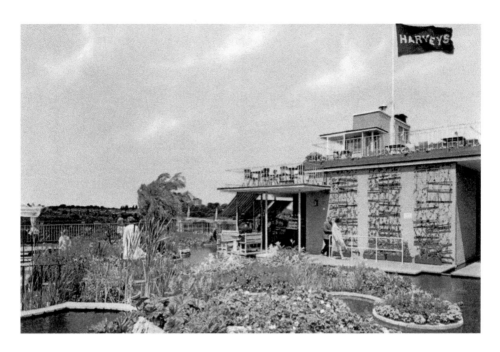

Roof Garden

Landscape architect Sir Geoffrey Jellico designed the rooftop garden on Harvey's department store in 1956-7. He later wrote that it was in part inspired by the first Sputnik spacecraft at that time flying high above the earth. As a result, the garden had a number of swirling and circular features reminiscent of the planets. Along with its restaurant and the goldfish in the ponds, the roof garden was a popular place to visit in the 1960s. It was later closed after some items of furniture were recklessly thrown from the roof. However, in recent years, when the store, now House of Fraser, received a substantial revamp, the roof garden was reinstated and is again part of the restaurant on the top floor.

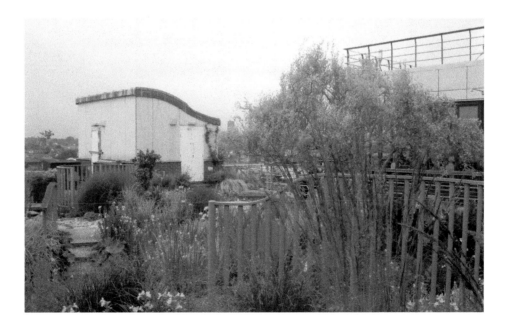

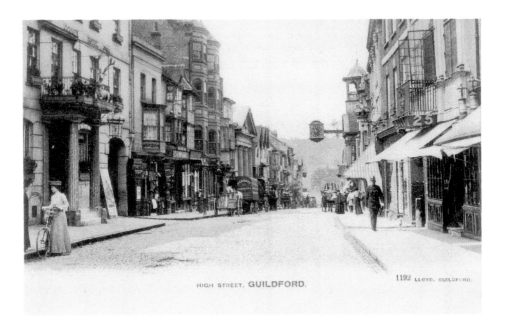

HIGH STREET, GUILDFORD.

1192 LLOYD, GUILDFORD.

The White Hart Hotel and Guildford House

A policeman takes a casual stroll up the High Street in a view from the turn of the twentieth century. On the left can be seen the White Hart Hotel complete with its statue of the antlered animal at first floor level. Compared with today's view, it's interesting to note that the railings on the first floor balcony and the windows of what is now Guildford House Gallery appear to be exactly the same as they were all those years ago.

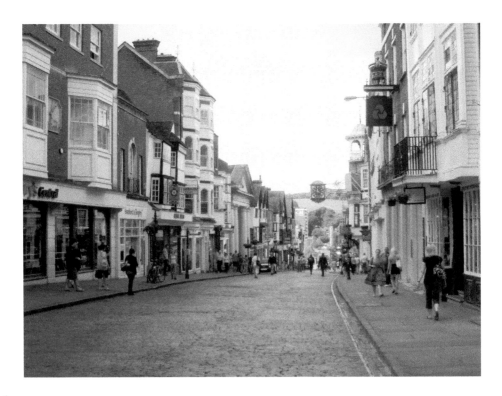

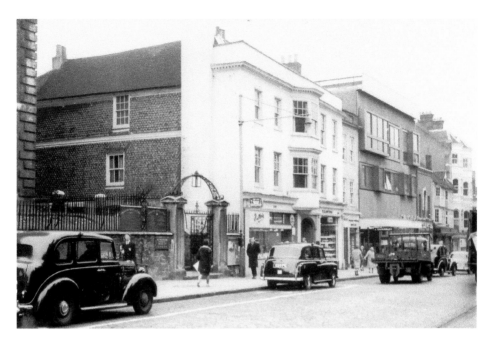

Sainsbury's and The County Club

Sainsbury's replaced the White Hart Inn in 1905 and later extended further down the street. In the view taken around the 1960s the ground floor of the white building is home to Fuller's confectioners and Lloyds Photographic Centre. Above was, and still is, The County Club — at one time a regular haunt of Guildford's 'movers and shakers'.

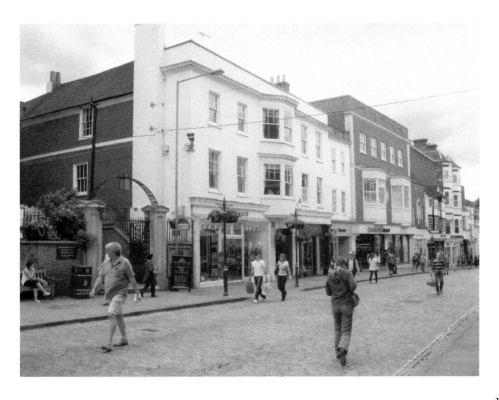

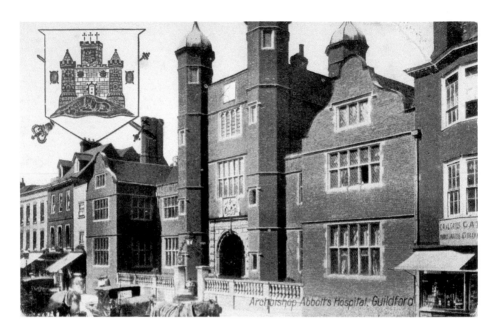

Abbot's Hospital

Abbot's Hospital is perhaps Guildford's most spectacular building. Archbishop George Abbot, the town's most famous son, laid the foundation stone in 1619. It is one of the best examples of Tudor brickwork in the south of England. The two views are about 100 years apart and little has changed during that time.

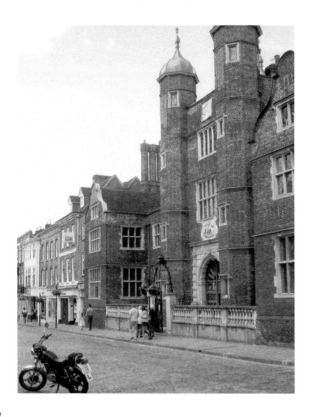

Entrance to Abbot's Hospital
Top hats and tailcoats were the
order of the day in this older
photograph that dates back to
the 1860s to '70s. They make an
interesting comparison to the
people seen in the photo taken in
2009. Abbot's Hospital has never
cared for the sick but was built as
an almshouse and still provides
homes for elderly people.

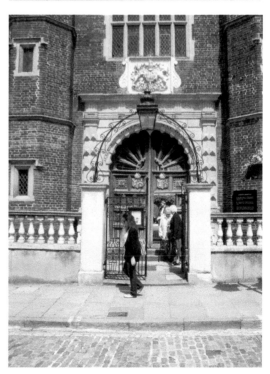

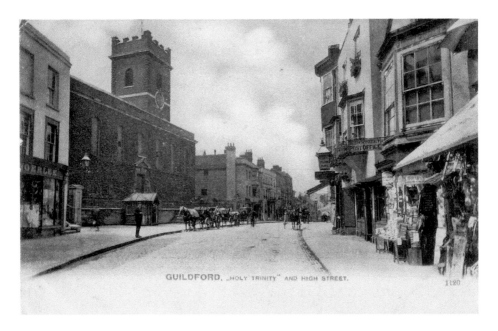

GUILDFORD, "HOLY TRINITY" AND HIGH STREET.

1120

Holy Trinity Church

Ivy adorns the north wall of Holy Trinity church in a view taken around 1900. It became the cathedral church of the new Diocese of Guildford in 1927, prior to the Cathedral of the Holy Spirit being built on Stag Hill. The road and pavement layout has now been altered and what was once the Three Pigeons pub on the right has more recently been renamed the Farriers.

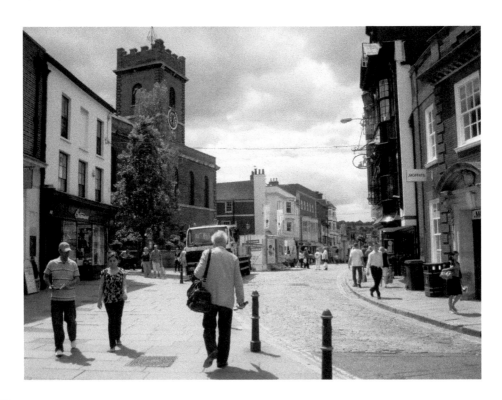

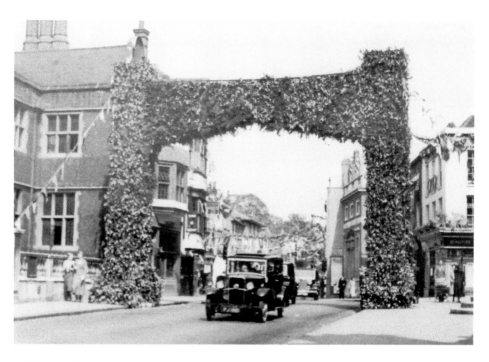

Jubilee Arch

A spectacular arch covered with greenery was erected at the top of the High Street to mark the silver jubilee of George V in 1935. Capturing Guildford as it looks today, there seem to be constant changes occurring, with alterations going on to buildings in the town centre.

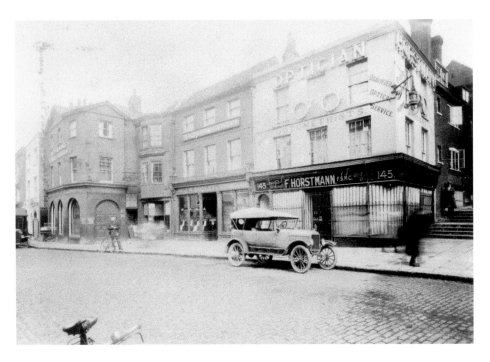

Eyesight on Opticians

Dating from the early 1920s, the older view clearly shows Horstmann's opticians with its giant pair of spectacles on the wall of the second floor. Today, it is Bateman's opticians. It just happened that featured in the current picture is a motorcycle, which seems to contrast nicely with the elegant convertible car in the earlier view.

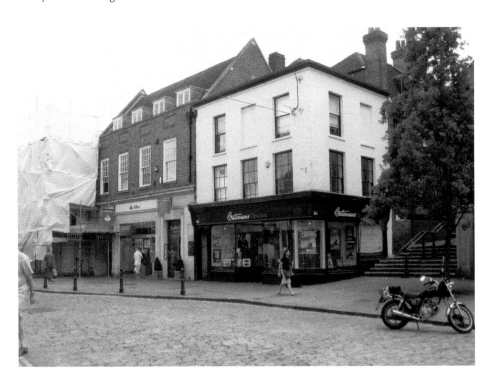

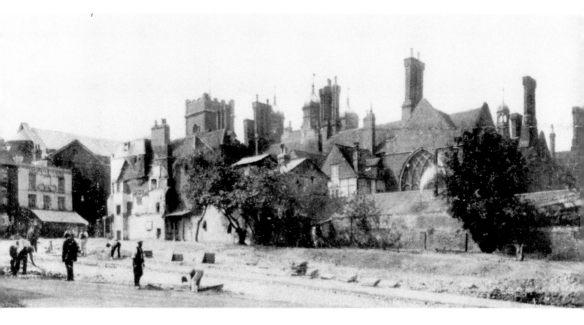

Top of North Street

Following the demolition of what was Ram Corner in 1913, this image reveals rarely-seen views of Abbot's Hospital. The building that is now the post office in North Street, and formerly a regional office of Barclays Bank, had once been the head office of the dairy firm Cow & Gate.

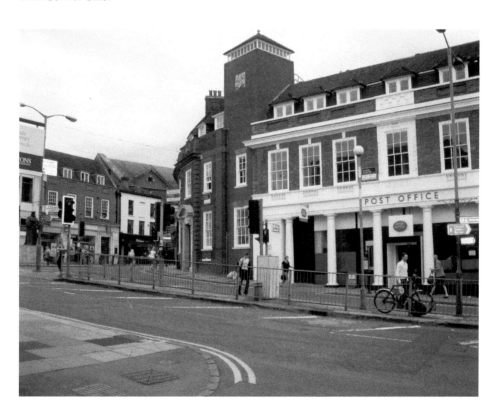

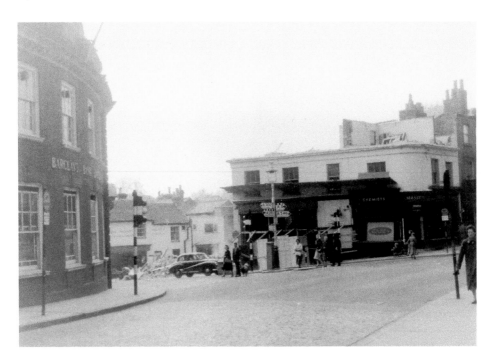

Massey's Corner

This image taken in 1959 shows more demolition and regeneration, this time at the junction of upper High Street and the top of North Street, formerly known as Massey's Corner, named after a chemist of that name who traded there. In the current photograph the scene is dominated by Faith Winter's statue of Archbishop George Abbot, which was unveiled in April 1993.

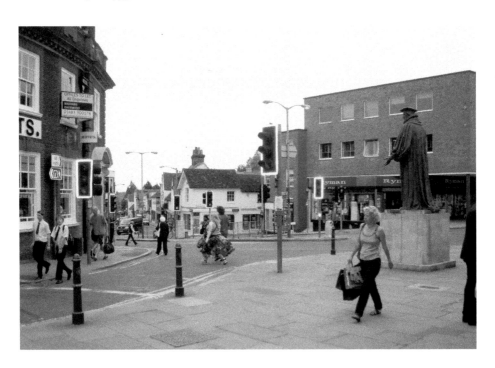

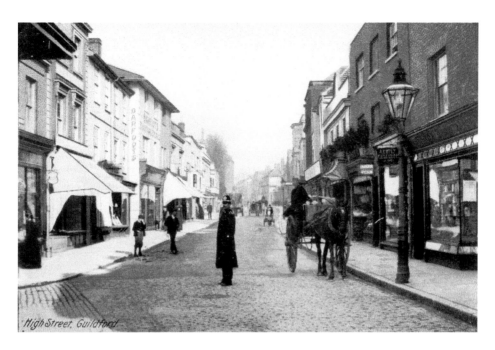

Upper High Street

During the 1950s it was decided to demolish the existing buildings on the left of the photograph. The replacement buildings were only supposed to be temporary but have stood the test of time. In the earlier image Barfoot's Paperhanging and Decorative Warehouse is on the left. The original owner of this firm was Joseph Whittaker Barfoot, founder of the *Surrey Advertiser*.

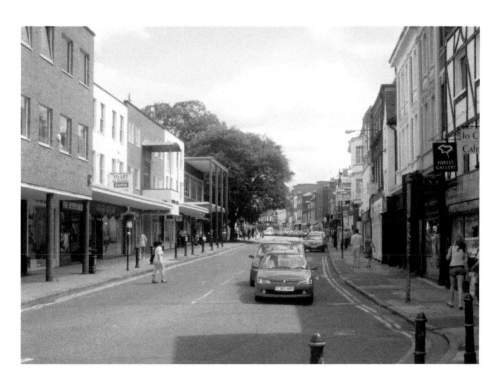

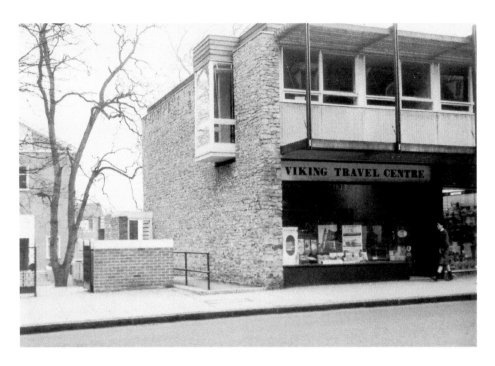

From Travel Agent to Coffee Shop

Viking Travel's origins can be traced back to 1964. It became Sovereign Travel in 1968, founded by Bill Inkster. He was a well-known member of the Guildford Lions, a Rotarian and Trade Secretary of the Guildford Town Show. Over the years this shop unit that is next door to the Royal Grammar School has had a succession of occupants.

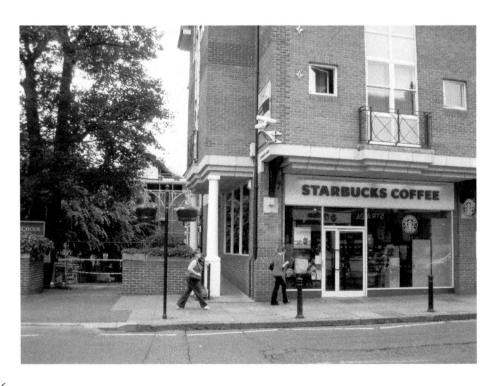

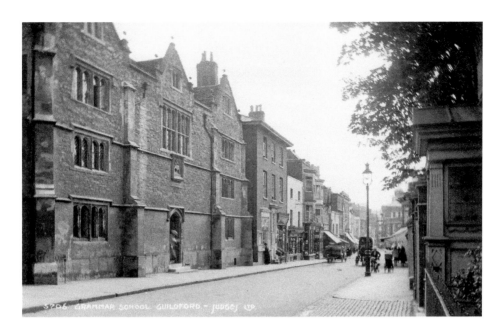

Royal Grammar School

Little has changed in this view of the upper High Street and the Royal Grammar School. Robert Beckingham, a wealthy London merchant, bequeathed money in his will for the building of a free school in Guildford. The town petitioned Edward VI for funds for its maintenance. Building work began in 1557. In 1977 it became independent and fee paying.

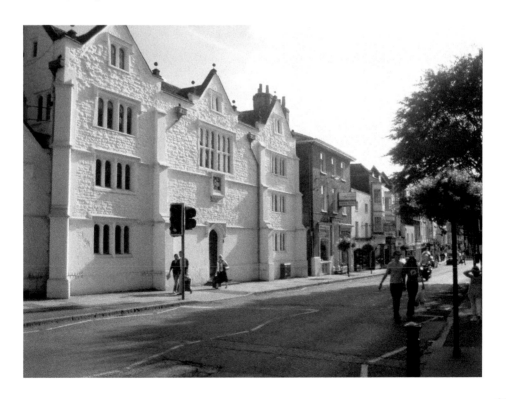

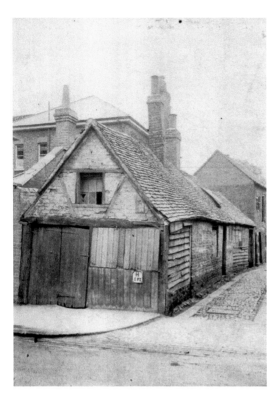

The Old Smithy
At about where McDonald's fast-food restaurant and neighbouring shops are today, in the upper High Street, was once a ramshackle building that was a smithy with an alleyway to the side. The smithy was run by the Lymposs family who were also dairymen.

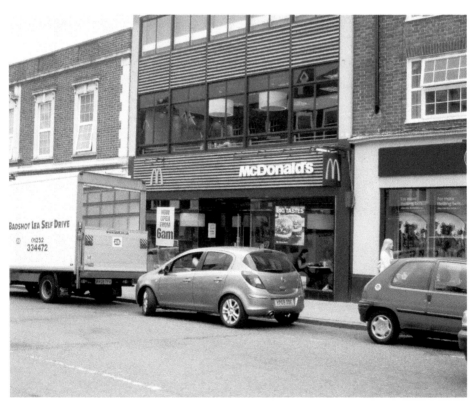

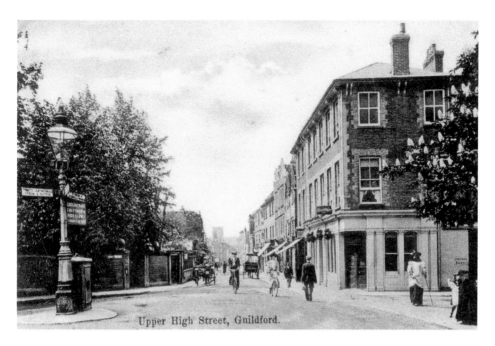

Upper High Street, Guildford.

Upper High Street with the Junction of Epsom Road

Behind all the trees in the Edwardian photograph was the imposing building and grounds of Belmont House. This was demolished during the 1930s and replaced by the Prudential Buildings. The building on the right-hand side was for many years the White Horse Hotel, now the Guildford Hotel.

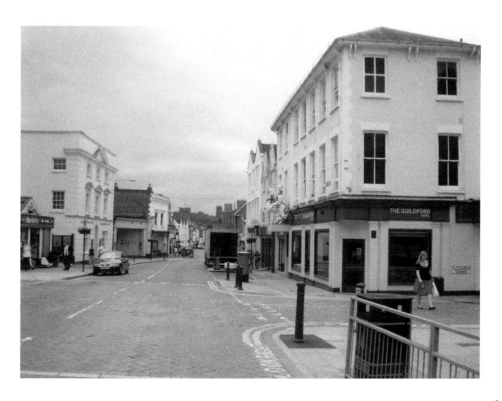

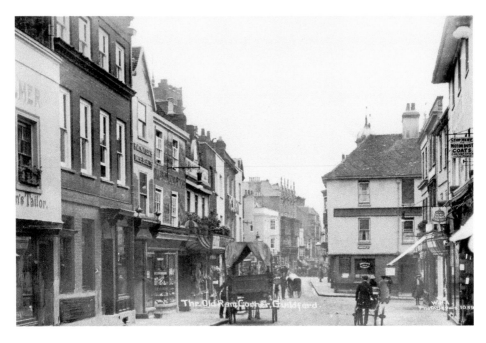

The Former Ram Corner

In the older view, looking back down the upper High Street, can be seen the Ram Inn that gave its name to Ram Corner. This pub and adjoining buildings were demolished to widen the road, alleviating traffic congestion.

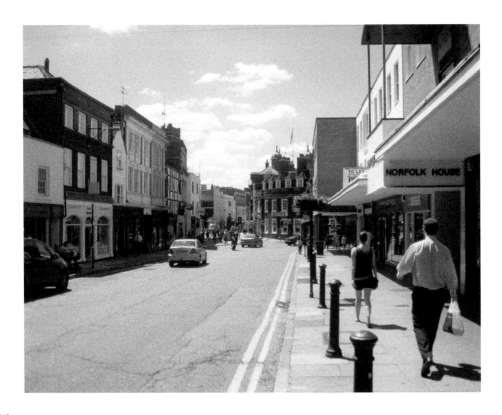

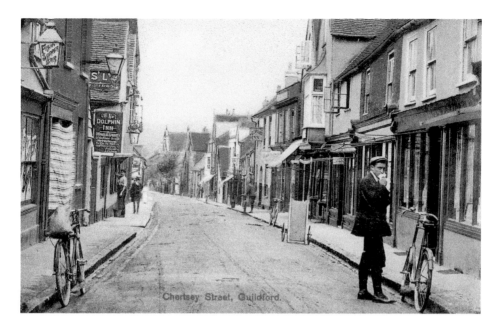

Chertsey Street

Two pubs, now long gone, were once here in Chertsey Street. On the left was once the Dolphin Inn and a little way further down on the right was the Leopard. In today's photos, the building on the left, which started life as a Habitat home furnishing store, is currently a Slug & Lettuce restaurant and bar. The shop closest on the right was until more recent times Messingers tool shop.

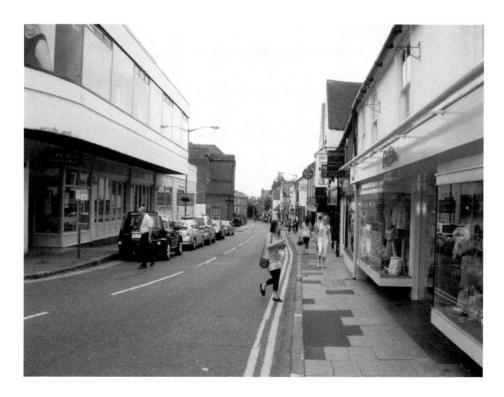

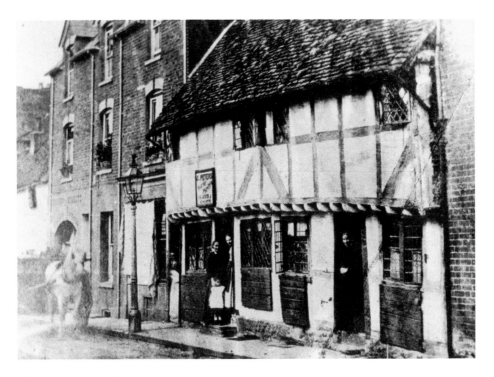

Old Cottages in Chertsey Street

Faces peer out from the doorways of a pair of half-timbered cottages in a picture from about the 1870s. G. Peters occupied the left-hand cottage. He was a house painter and decorator who also bought and sold antiques. There is no trace of these cottages today. The first and second storey windows of solicitors Wright & Wright (next to the Rose Valley restaurant) appears to be the only feature that can be seen in both photos.

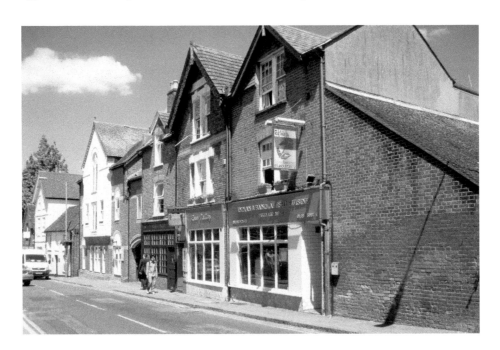

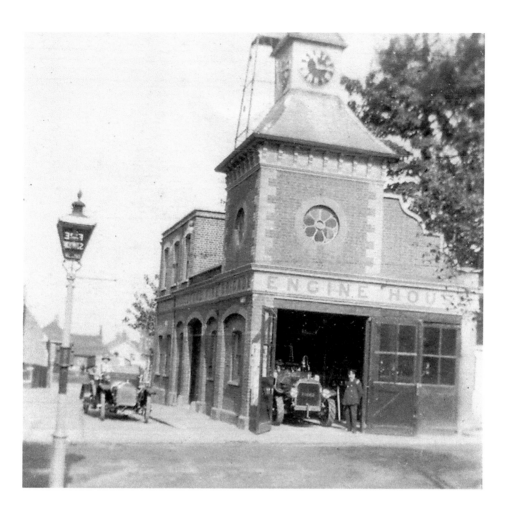

The Old Fire Station in North Street
This 1920s view shows the fire station when it was in North Street. It was opened in 1872 and was used until the brigade moved to its present fire station at Ladymead in 1937. Today, the North Street building is a public lavatory. It seems a shame that the words 'GUILDFORD FIRE BRIGADE ENGINE HOUSE' are no longer visible along the front and side of it.

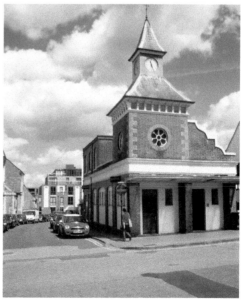

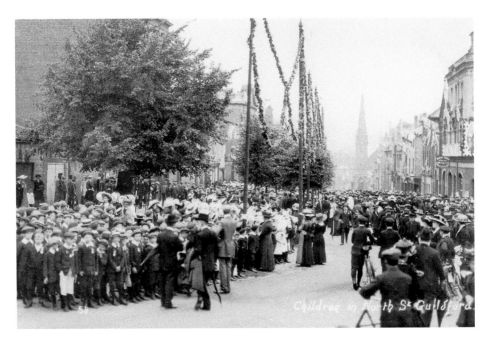

George V's Coronation Celebrations in North Street

A large crowd has gathered in North Street to watch the Grand Procession of some thirty-seven floats as part of Guildford's celebrations to mark George V's coronation, on 22 June 1911. Today's photo was taken mid-morning on a Sunday, and already all the car parking spaces here have been filled.

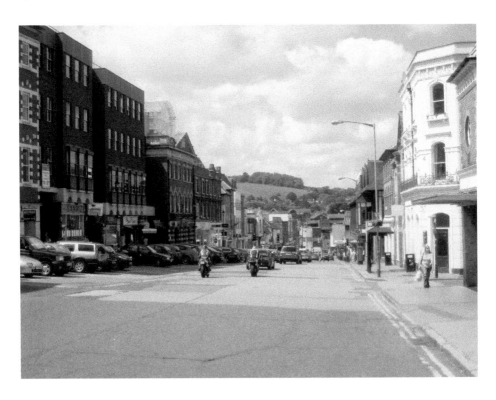

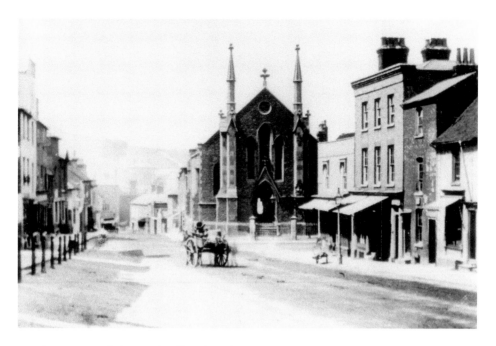

North Street and the Methodist Church

The nineteenth-century photo shows the first Methodist Church that stood on the corner of North Street and Woodbridge Road. Built in 1844, it was never a particularly satisfactory building and was replaced in 1894 by a new church with a tall spire. Dominant in today's photo, with its slanting windows, is the 1970s building that until recent years was the main post office.

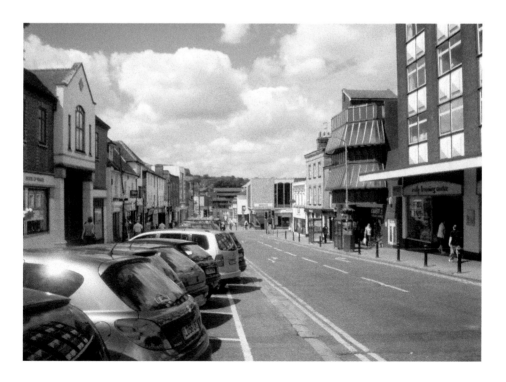

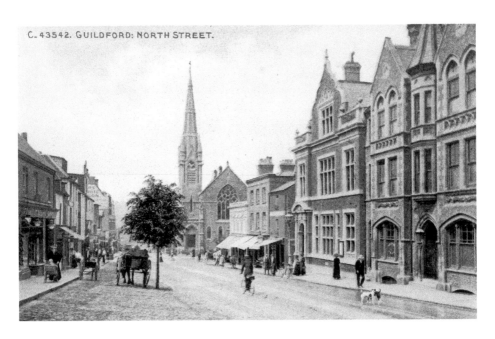

Sad News at the Post Office

The previous red-brick post office can be seen in this photo from the 1910s. It was here that the American-born writer Mark Twain, while briefly staying in Guildford, spent a night waiting for a cable containing news of the condition of his sick daughter. When it came, it confirmed that sadly she had died. Today's photo shows that the second Methodist Church no longer stands. It was, in fact, pulled down in 1973.

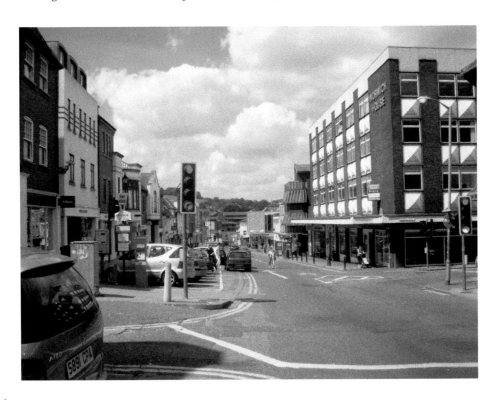

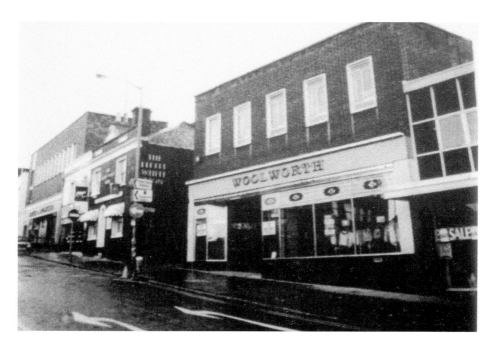

Woolworth's to White Lion Walk

Today's stylish North Street entrance to the White Lion Walk Shopping Centre is more appealing than the building that housed F. W. Woolworth & Co.'s store. However, many will fondly remember that store. At one time its food hall was at this end of store, with clothing, the record department and other goods sold at the High Street end. In the earlier photo the Little White Lion pub can also be seen.

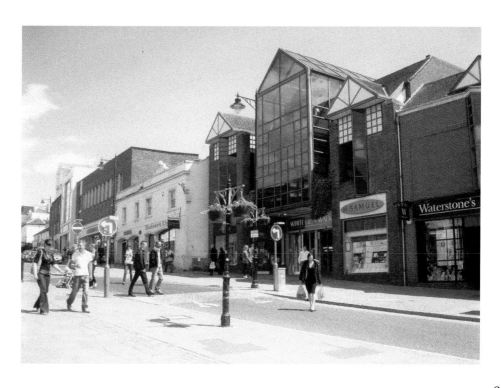

North Street Shops
The building may be the same, but the passing of time, about twenty-five years between these two pictures, shows how traders have come and gone. And traffic-calming speed humps are another addition to the town centre scene.

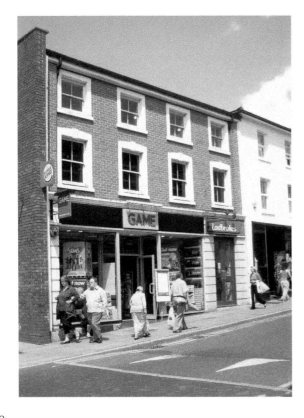

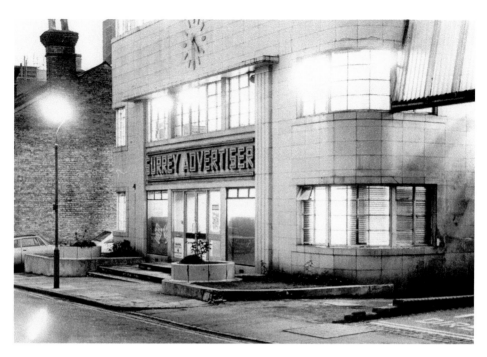

Surrey Advertiser Offices and Print Works in Martyr Road

Built in the art deco style with cream-coloured tiles and curved metal window frames, the *Surrey Advertiser*'s offices and print works were unique to the town centre. The building was demolished in 2002, with plans by its developers to construct offices with a similar 1930s-style frontage. Those plans were changed, apartments have recently been built instead and the development is called Printing House Square.

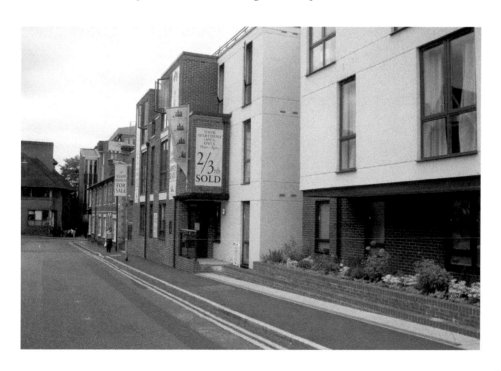

North Place

Beverley Hall for the Deaf is seen on the corner of North Place and Stoke Fields in the older view that dates to about the 1970s. Cottages once stood on the left-hand side. As can be seen from today's picture, homes for elderly people were built there. In recent times, the hall was used by Guildford School of Acting.

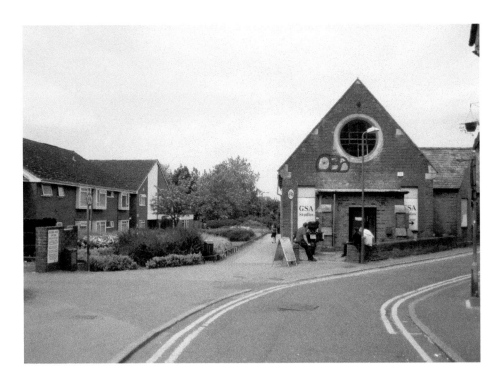

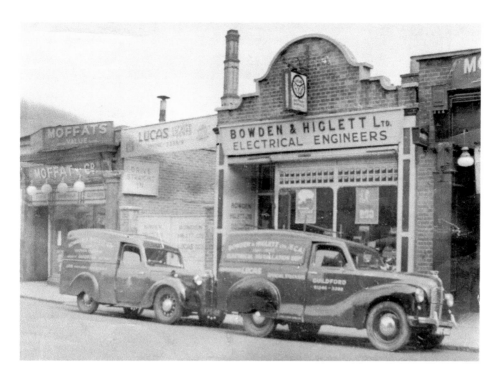

Onslow Street Businesses

A number of businesses once occupied premises along Onslow Street. Here we see electrical engineers Bowden & Higlett and clothes retailer Moffats. The chimney of the Friar Brewery can be seen in the background. The brewery and adjoining buildings were pulled down in the early 1970s and Guildford's major shopping mall, the Friary, was built in its place.

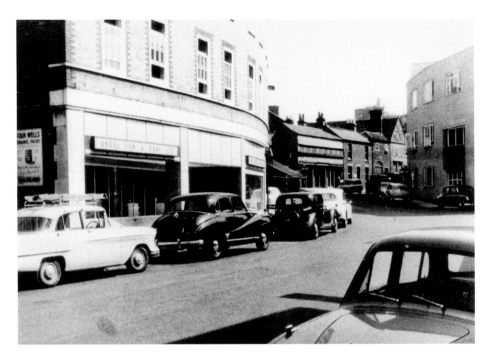

Angel Son & Gray in Woodbridge Road

Building materials and supplies firm Angel Son & Gray had premises on both sides of Woodbridge Road. The 1960's view reveals that parking your car along here wasn't a problem. Today, it is another part of the town clogged up with traffic waiting to pass through the lights that control the flow along Woodbridge Road, Leapale Road and from the bus station in Commercial Road.

Friary Street

Friary Street was pedestrianised in the 1970s. In the view taken a few years after, shops included Hardy's menswear, Dalgety frozen foods and Tesco. As can be seen, in the past year Friary Street has had a major revamp giving the shop units a bright new look. On the left-hand side of today's picture can be seen one much older building that has survived the changes. It was once the Bear pub.

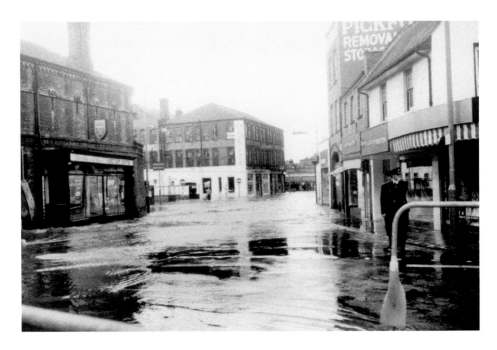

Rodboro Buildings, Onslow Street

A flooded Onslow Street in September 1968. The Rodboro Buildings in the centre of the photo was then occupied by a number of shops and businesses including Clare's Motor Works. The building is believed to be the world's first purpose-built car factory. It was erected in 1900 for the then rapidly expanding motor manufacturers Dennis Bros. Today, the building is a Wetherspoon's pub and home to the Academy of Contemporary Music.

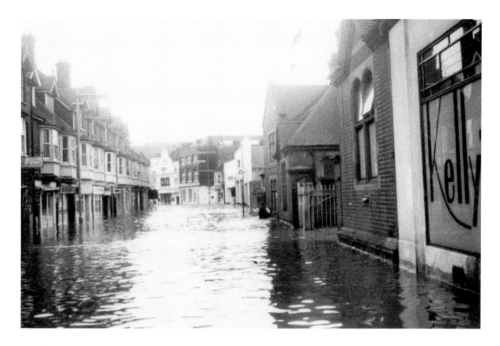

Onslow Street

The River Wey burst its banks on the evening of Sunday 14 September 1968, after a day and a night of exceptionally heavy rain. The older photo was likely to have been taken on the Monday, by which time this part of Guildford was badly flooded. Much development has taken place since then including the Friary, with its shops and flats above and a number of offices on the right-hand side where the town's gas works once stood.

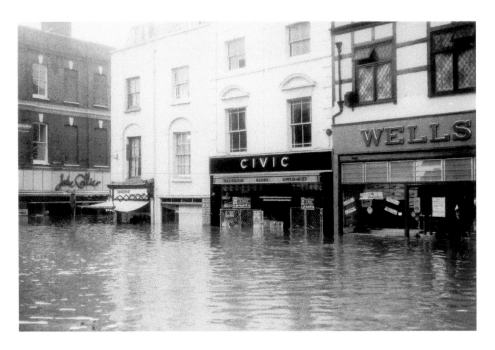

Floods at the Foot of the High Street

Comparing these two photos, it can be seen just how deep the water was at the bottom of the High Street near the corner of Friary Street in 1968. As the waters flooded into the shops on the Sunday night and the early hours of the Monday, there was, of course, no one around to salvage any goods. As a result, thousands of pounds worth of stock was ruined.

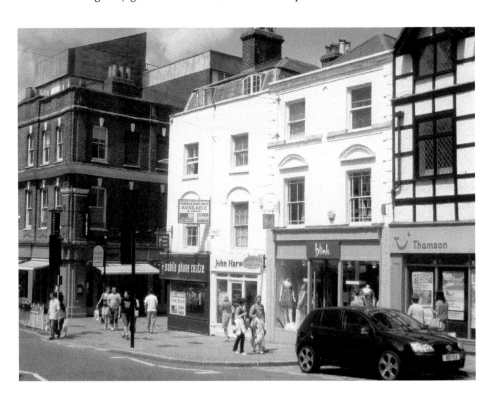

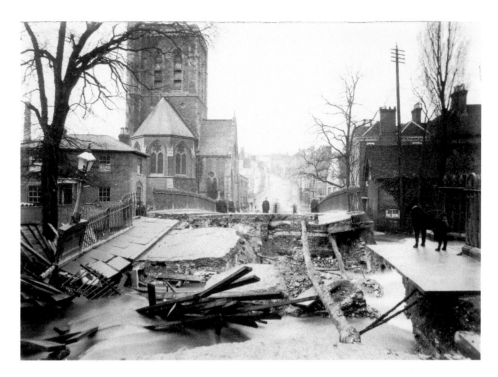

The Town Bridge

A swollen river dislodged timbers at Moon's yard and brought them crashing into the Town Bridge in January 1900 causing some spectacular damage. The bridge was completely rebuilt, opening two years later. The bridge that spans the river today dates back to 1985, and is for pedestrian use only.

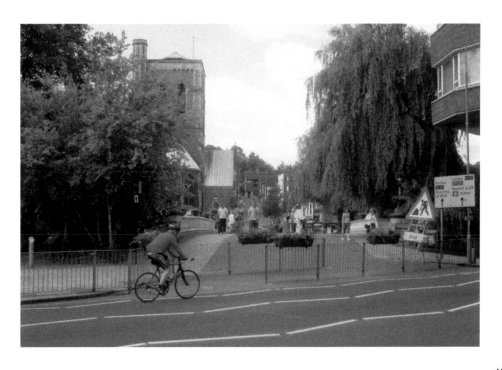

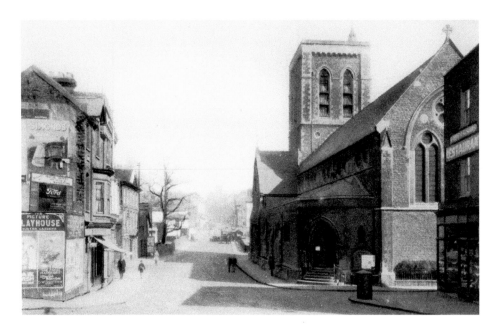

St Nicolas' Church

This view, looking up towards the High Street from the opposite side of the river, has not changed a great deal. But look carefully at today's photo and you will notice that one building on the left-hand side has gone. It was called Guildford House and was the home of the Crooke family whose brewery was beside the river. St Nicolas' Church was consecrated in 1876. It replaced an earlier short-lived nineteenth-century church that was very poorly designed, uncomfortable for worshippers and had a leaky roof!

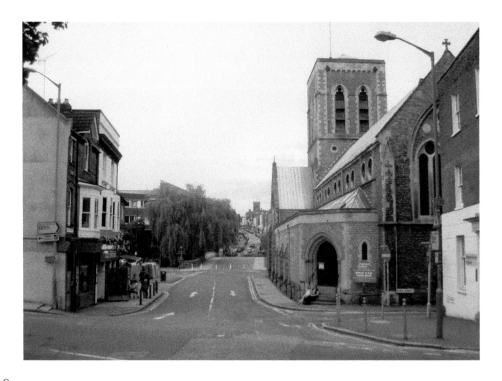

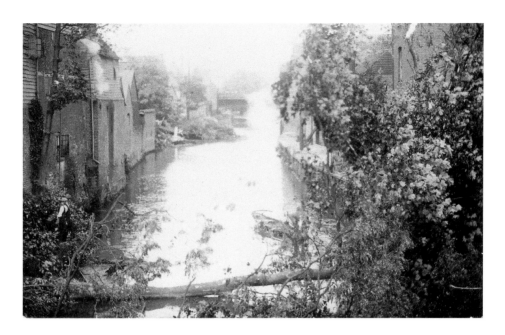

River Wey and the Town Wharf

The message written on the back of the old picture postcard suggests that it was taken to show the effects of Guildford's great storm of August 1906. On the left-hand side are the buildings of Crooke's Brewery. The town wharf was on the opposite side. This is now an open space, but the old treadwheel crane housed in its wooden shed has been preserved and there is a statue titled The Bargeman as a reminder of what was once here.

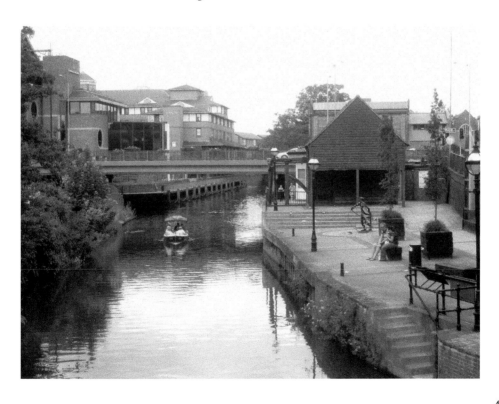

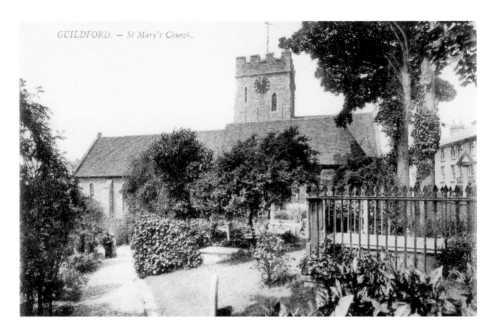

GUILDFORD. — St Mary's Church.

St Mary's Church

The tower of St Mary's church dates back to Saxon times making it the oldest building in the town. This ancient building was undergoing some important restoration work in 2009 as seen in the photo. The Victorian wooden pews have also recently been removed and replaced with comfortable, modern chairs. As well as a place of worship, St Mary's also hosts secular events such as concerts.

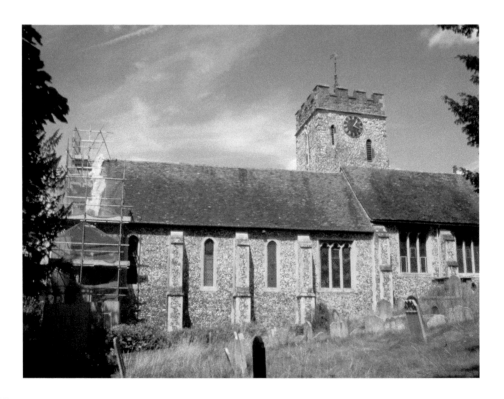

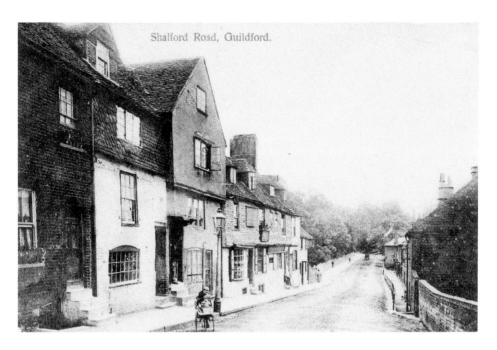

Shalford Road, Guildford.

Quarry Street leading to Shalford Road

The line of buildings on the left with stone steps leading up to the front door seen in this 1900s postcard included the Good Intent beer and lodging house. On the opposite side of the road there were also a number of cottages. These were pulled down nearly fifty years ago to make way for the Millbrook development.

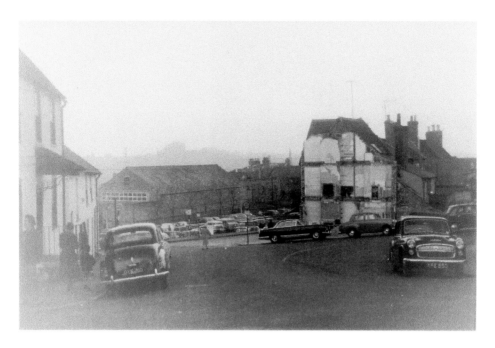

Tunsgate Square

Looking towards Tunsgate from Pewley Hill in a photograph taken in 1959. The building beyond the parked cars is the Playhouse Cinema, which was at the end of an arcade of shops with an entrance from the High Street. The arcade is now part of the Tunsgate Shopping Centre, which underwent considerable redevelopment during the 1980s.

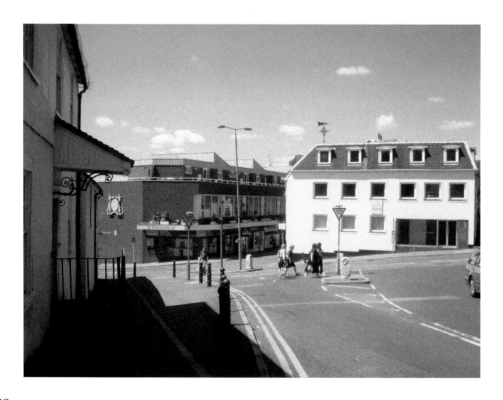

Car Park in Sydenham Road
Demolition had been taking place in this 1959 photograph to make way for a multi-storey car park, which was opened in 1963. In the 1990s it was found to be structurally unsafe. It was pulled down and replaced by a new car park whose architecture is an improvement on the previous building.

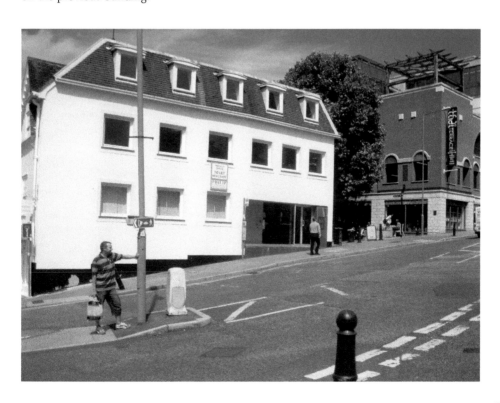

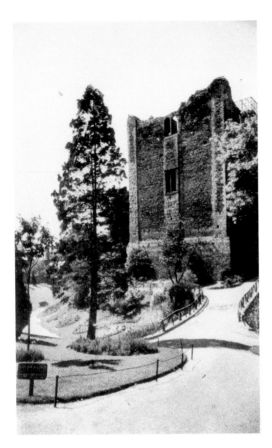

The Castle Keep

The stone keep of Guildford Castle was built during the middle of the twelfth century following earlier fortifications believed to have been started soon after the Norman invasion of 1066. The corporation purchased the castle buildings and its grounds, opening them to the public in 1888. Comparing the two pictures that are more than sixty years apart, the style of the flowerbeds has not changed at all.

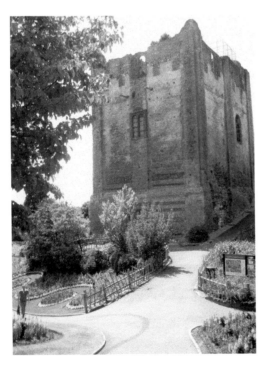

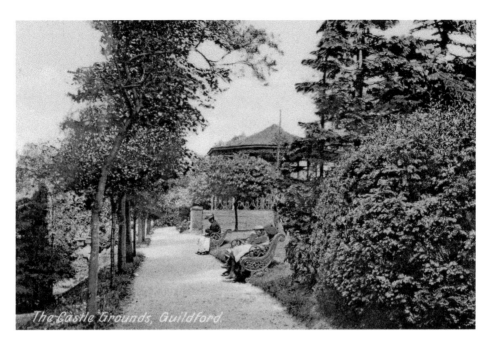

Castle Grounds Bandstand

Guildford's town surveyor Henry Peak designed the layout of the Castle Grounds including many attractive features such as the bandstand. It is still in use today and the trees have reached maturity.

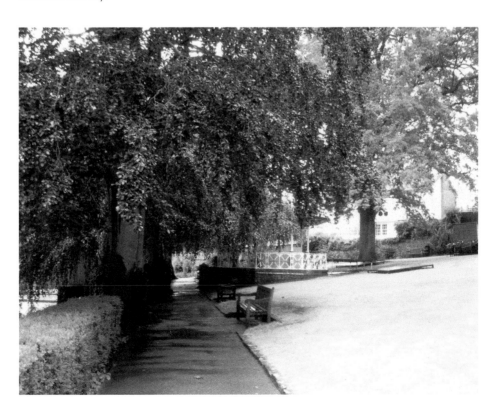

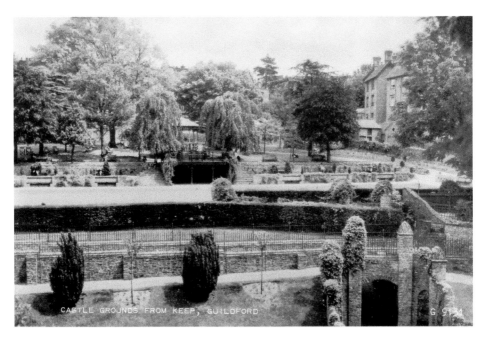

View from the Keep

Peak's designs have certainly stood the test of time and there are very few differences to be seen comparing this mid-twentieth-century view with today's photo.

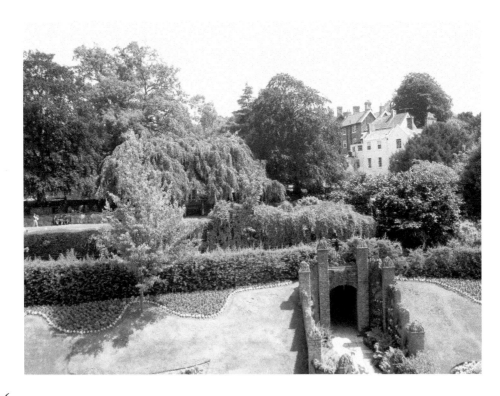

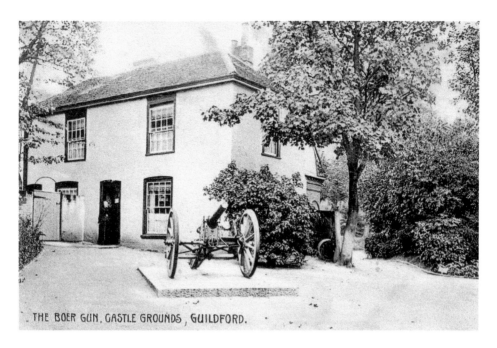

THE BOER GUN, CASTLE GROUNDS, GUILDFORD.

The Field Gun in the Castle Grounds

This field gun, made by Krupp of Essen, was captured during the Boer War (1899-1901) and presented to Guildford in recognition of its support for the war effort. It occupied at least two sites in the Castle Grounds and is seen here near the entrance with Castle Street. It disappeared many years ago, melted down for its metal that was used in a later conflict.

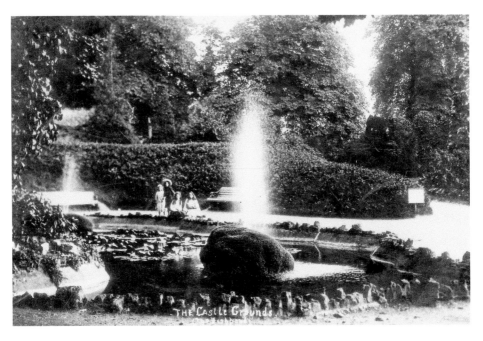

Henry Peak's Pond

The pond was another of Henry Peak's clever designs within the Castle Grounds. Slightly different in layout today, it has recently had some restoration work and is still a popular spot for young and old alike.

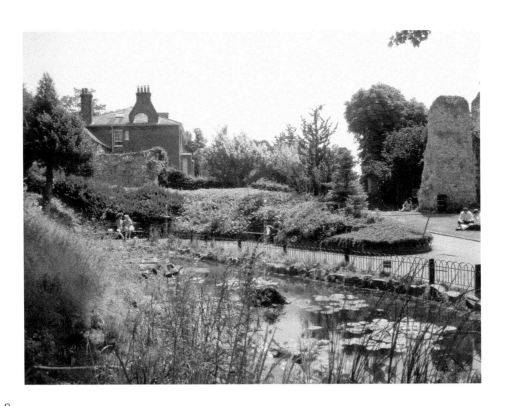

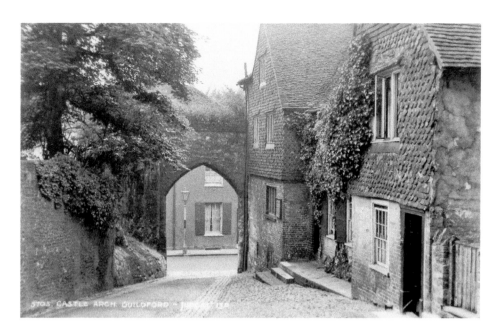

Castle Arch

Henry III's master mason, John of Gloucester, is believed to have built the impressive stone arch in 1256 that formed the gate to Guildford Castle. It is made of a hard type of chalk known as clunch and at the time of writing is undergoing restoration. The building on the right dates back to 1630 and today is the home of the Surrey Archaeological Society and Guildford Museum.

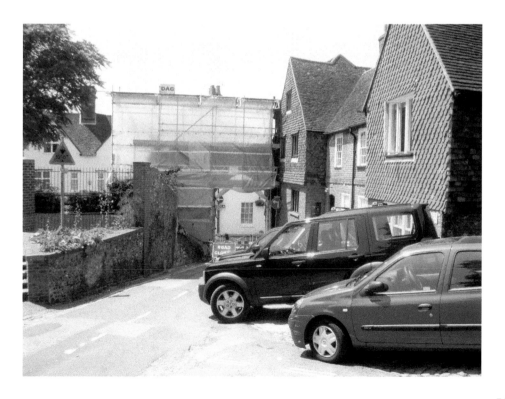

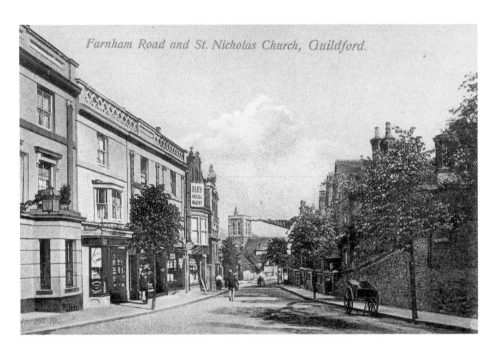

Farnham Road and St. Nicholas Church, Guildford.

Farnham Road

The road is now part of Guildford's gyratory system and on the far left of the older view is the Napoleon Hotel. Some of the later traders who occupied the buildings on the left, now long gone, included estate agents and auctioneers Heath & Salter, Brett's bakers and Arthur Cooper wine and spirit merchants.

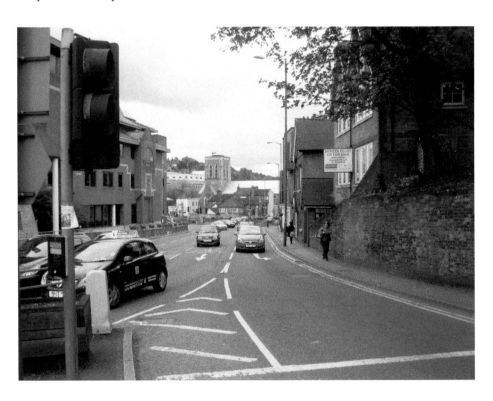

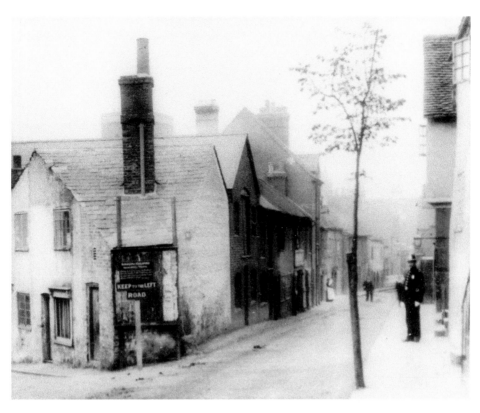

Park Street

Even in the 1900s when the older view was taken there was a one-way street here. The tower of St Nicolas' church can just be glimpsed behind the buildings, and is the only feature that has made it possible to locate the scene for today's photograph.

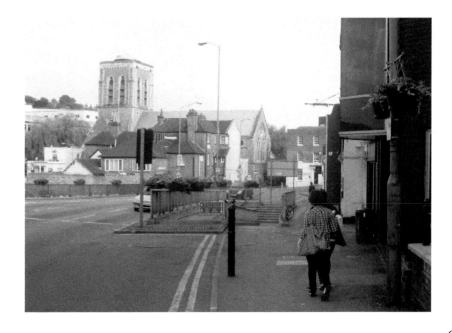

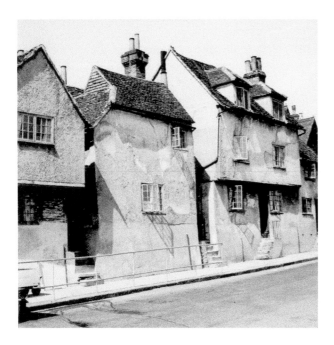

The Old Cottages in Park Street and Farnham Road

Many Guildfordians were disappointed when the old cottages on the west side of Park Street and Farnham Road were pulled down in the late 1950s. The building with large smoked glass windows seen today was, from around the 1970s, home of a Swiss Restaurant and later a Chinese restaurant.

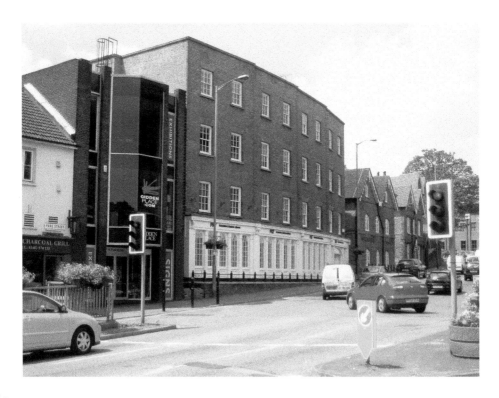

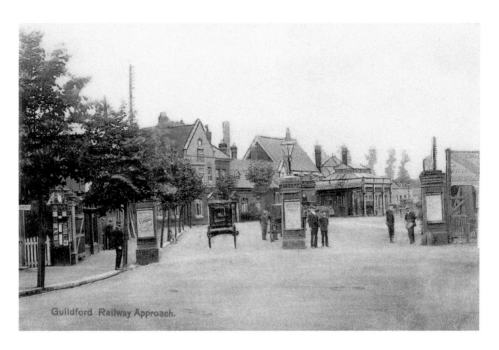

Guildford Railway Approach.

Guildford Railway Station Approach
When the railway station was rebuilt in the late 1980s a scene that had remained unchanged for over 100 years disappeared. The wide expanse that was in front of the older buildings is now used for much-needed car parking spaces.

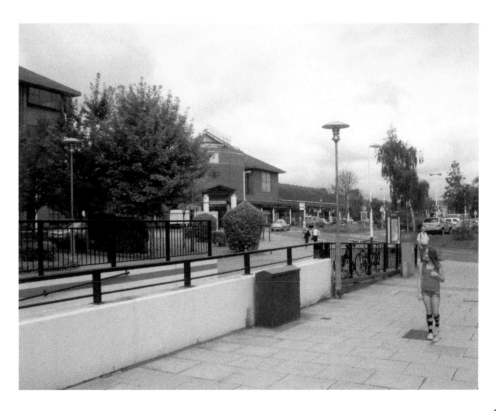

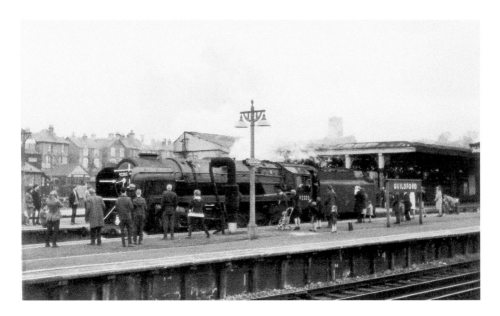

Steaming through Guildford

Guildford Railway Station was packed with people on Sunday 7 April 1968, to see two steam locomotives pass through on the way to their new home at the Longmoor Military Railway in Liss, Hampshire. The artist and conservationist David Shepherd had bought them from British Railways. Seen here is 9F class loco, number 92203, which the artist later named *Black Prince*. Today, the locomotive is based at the heritage line, the Gloucestershire Warwickshire Railway.

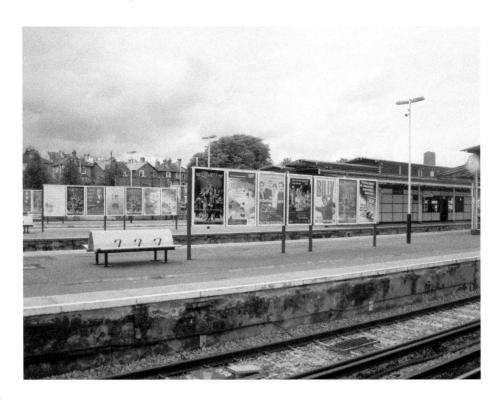

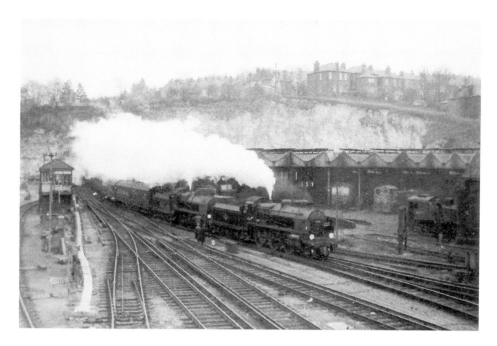

Farewell to the Engine Shed

The double-headed steam train was on a rail tour when it came through Guildford on 3 April 1966 and is seen passing the engine shed. When British Rail withdrew steam locos on the Southern Region in 1967, the shed was closed. Today's photograph shows the multi-storey car park that replaced it and a modern South West Trains electric unit.

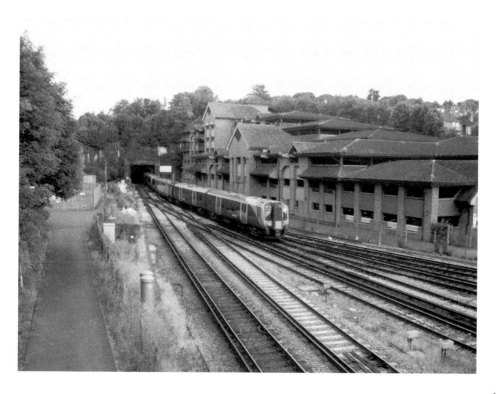

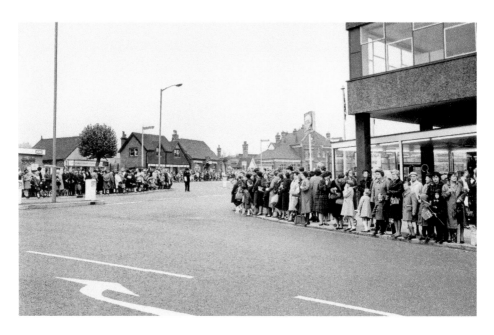

Station Approach from Bridge Street

Crowds gathered to catch a glimpse of the Queen as she arrived at Guildford Station in 1964. She continued her journey by car to open the new Women's Royal Army Corps camp at Stoughton. On the right is Bridge House, which had a petrol station at ground level with the office block above. It was replaced with the current building at the end of the 1980s.

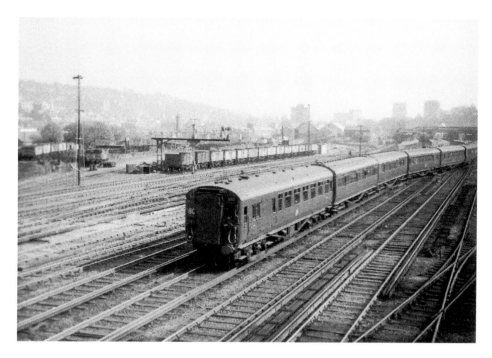

Yorkie's Bridge off Walnut Tree Close

Dating from 1965, a train departs Guildford for London Waterloo. Comparing it with today's view, note back then the lines of wagons in what was once a goods yard now taken up by a car park, a builders' merchant and a modern office building. On the skyline in the older picture are Bridge House and the Central Electricity Generating Board building.

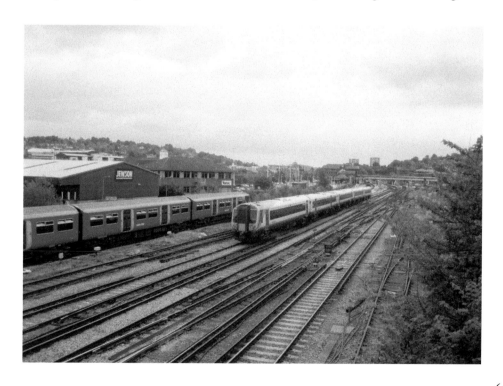

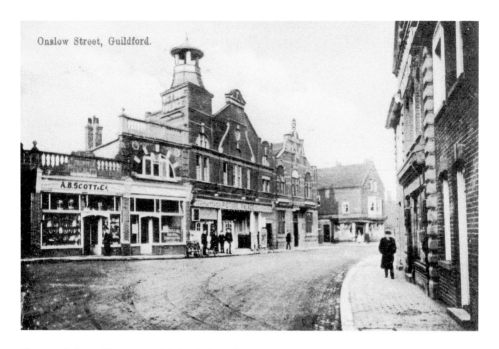

Picture Palace Cinema to Nightclub and Bars

The Picture Palace cinema is seen here in the early twentieth century, with Shelvey's mineral water factory next door. The latter became the offices and printing works of the *Surrey Times* newspaper until 1964, while the cinema later changed its name to the Plaza and eventually became a bingo hall. Today, these buildings are nightclubs and bars owned by local entrepreneur Michel Harper.

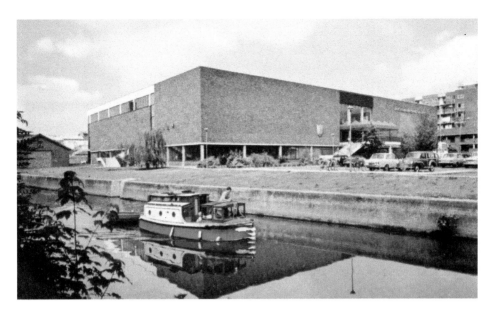

Guildford Sports Centre, now an Odeon Cinema stands here

Princess Anne opened the Guildford Sports Centre in Bedford Road. Its three pools were a vast improvement on the old Castle Street swimming baths, not to mention a hall ideal for five-a-side football, badminton, and so on, plus squash courts and an upstairs bar and café. It closed when the Spectrum leisure complex was opened in Stoke Park. Today, an Odeon cinema and the Old Orleans bar and restaurant stand on the site. The footbridge, seen in today's photo, was opened in 1986.

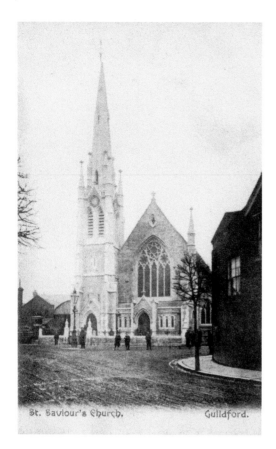

St. Saviour's Church. Guildford.

St Saviour's Church

St Saviour's church was newly
built when this early 1900s picture
postcard view was taken. Today this
Anglican church in Woodbridge
Road thrives — with large
congregations and visitors to its
services of worship and events that
take place throughout the week.

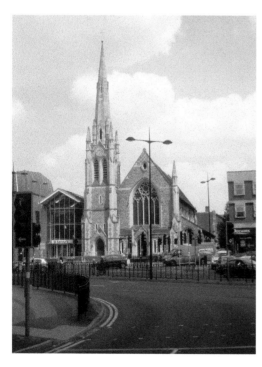

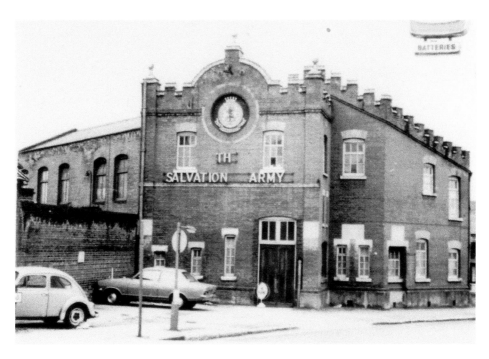

Salvation Army Building in Laundry Road

Guildford's Salvation Army citadel was in Laundry Road, off Woodbridge Road. The road itself still exists, going through to Bedford Road and servicing the car park, but otherwise the scene is unrecognisable.

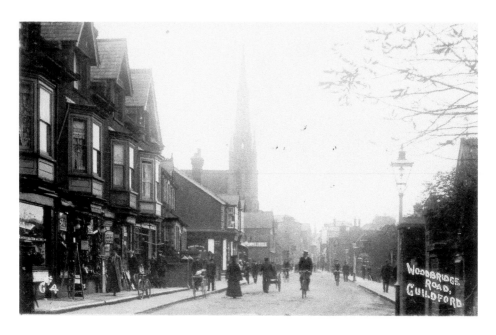

Woodbridge Road looking East

This busy Edwardian view, before motor vehicles reigned supreme, features cyclists and pedestrians in the middle of the road and a man pushing a handcart. What a difference in comparison to the scene now with traffic negotiating the roundabout at the junction of Woodbridge Road and York Road.

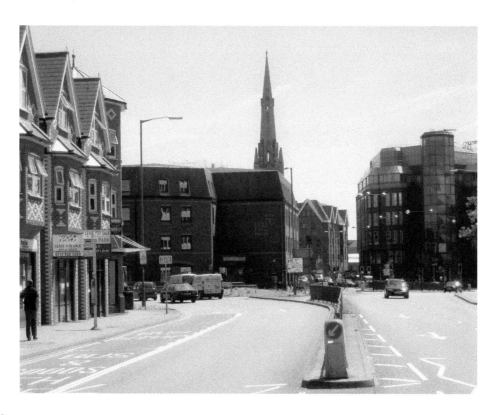

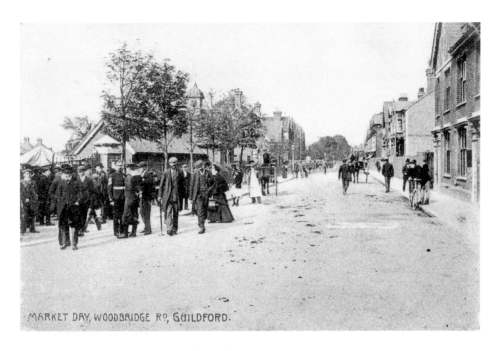

MARKET DAY, WOODBRIDGE RD, GUILDFORD.

Woodbridge Road and the Cattle Market

People continue to stand in the road, some having an idle chat, in another Edwardian view that appears to have been taken on market day. The cattle market was held here every Tuesday until it moved to Slyfield Green. Today, Guildford Police Station occupies part of the former market site.

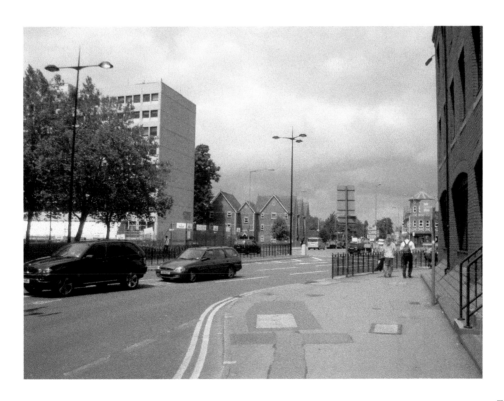

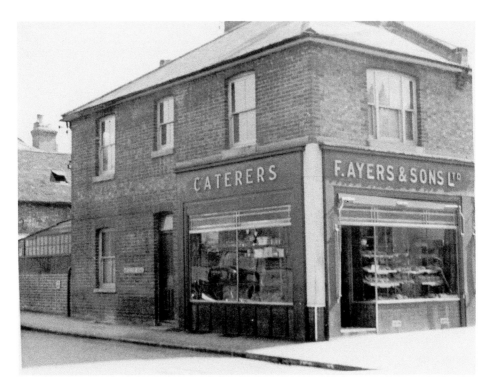

Artillery Road

Ayers' bakery stood on the corner of Artillery Road and Woodbridge Road. It had a number of shops around the town, in High Street, Onslow Street, North Street, plus two in Stoughton. The firm baked the special plum cake for the Queen when she visited Guildford in 1957. A modern building stands on the site today.

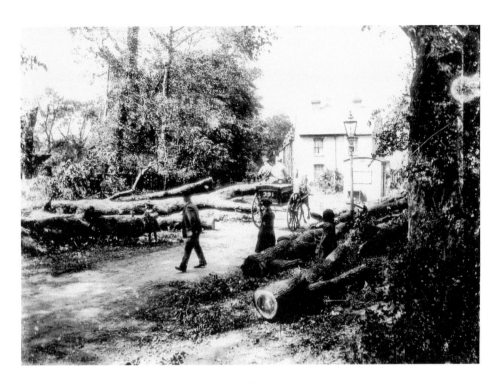

Woodbridge Road and the Great Storm of 1906

It was near this spot that a young woman and a boy died when trees they were sheltering under fell on them, brought down by Guildford's Great Storm of 1906. This photo must have been taken a short time afterwards when the road had been re-opened. Today, there is nothing whatsoever to indicate that this stretch of Woodbridge Road had once been a leafy thoroughfare.

Avenue Terrace

Seen in the 1960s picture is the row of houses that once made up Avenue Terrace along Woodbridge Road. They are another feature, once so familiar on the way into town, now consigned to 'lost Guildford'.

Ladymead

The 1968 floods were much photographed. In this view we see cars, cyclists and pedestrians at the junction of Ladymead and Woodbridge Road picking their way through the surface water. Note the once common double-decker Aldershot & District bus. Today, the Ladymead Retail Park is on the left with the once popular Bridge Café and neighbouring houses long gone.

Stoke Roundabout

At one time motorists had the unenviable hazard of negotiating the busy roundabout that formed the junction of Stoke Road, Woking Road, Ladymead and Parkway. It was a relief for many when it was replaced with traffic lights. The 1980's photo shows the temporary huts used by those employed building the new stretch of the A3 to the left of here. The Parkway hotel, bar and restaurant stands on the site today.

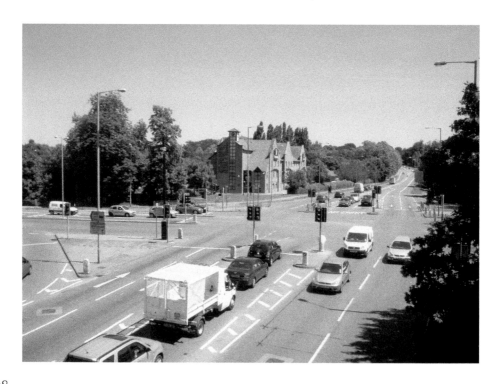

St John's Church, Stoke Road

For centuries, St John's church, Stoke-next-Guildford, must have stood in relatively open countryside. Stoke Road, on which it stands, is now one of the busiest thoroughfares into the town centre. The earlier view, taken in about 1900, shows a different clock to the one on the church today. Buried at the church is Sir James Stirling (1791-1865), the first governor of Western Australia. He married Ellen Mangles there on 3 September 1823, on her sixteenth birthday. She was from a wealthy Guildford family. They had six daughters and five sons.

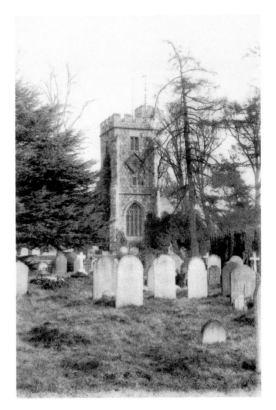

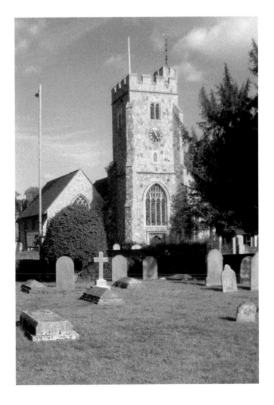

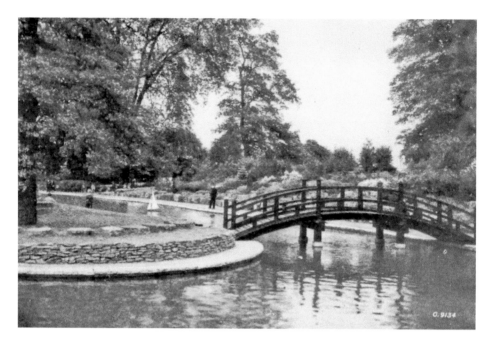

The Boating Pond, Stoke Park

The 186 acres of Stoke Park was purchased by Guildford Corporation in 1925 to be used as a public open space. In 1935, an ornamental Japanese-style paddling pool, rock garden and boating pond was opened.

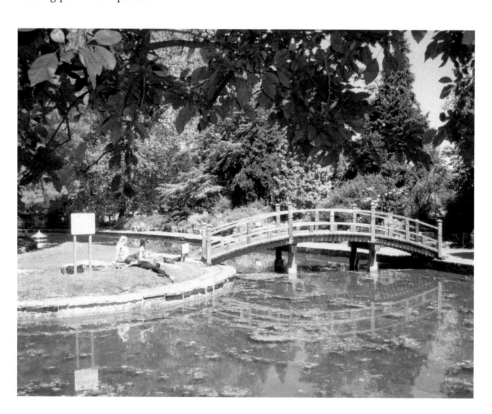

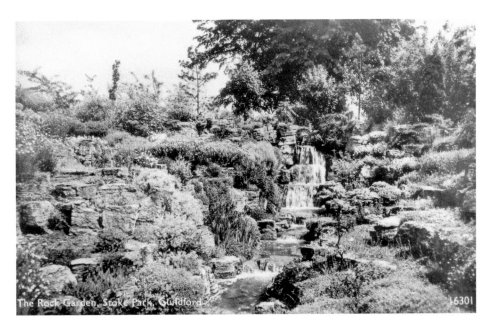

The Rock Garden, Stoke Park

The rock garden was constructed complete with waterfalls. Although it remains virtually the same the water no longer flows over them.

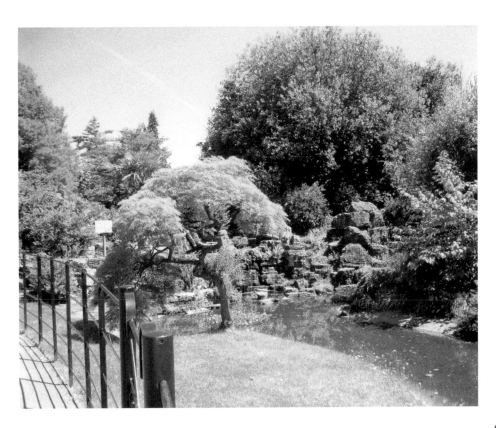

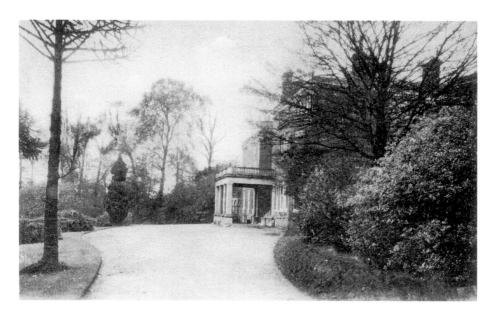

Stoke Park Mansion

The house that stood here had a varied history. It was at one time a private school and then during the Second World War was used as a telephone exchange — being one of a number of such centres handling calls as part of the UK's defences. Afterwards it was used as an annexe to the technical college. But by the 1970s it was in a poor state, deemed unsafe and suddenly razed to the ground. Nothing remains today, the site being one of Guildford College's car parks.

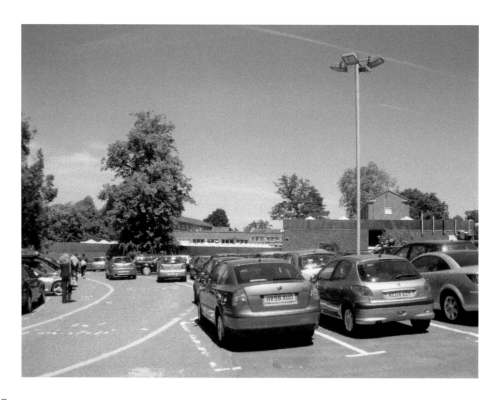

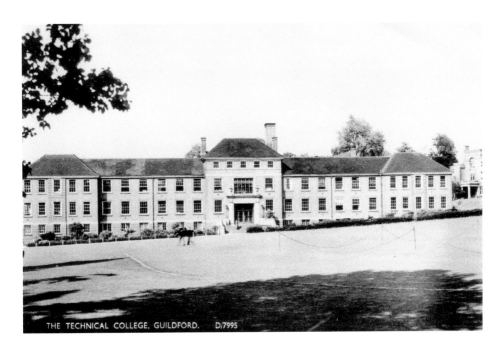

THE TECHNICAL COLLEGE, GUILDFORD. D/7995

Guildford College

Opened in 1939, parts of Guildford Technical College were immediately requisitioned for the war effort. It has expanded over time and in 1992 it became Guildford College of Further and Higher Education. Merrist Wood College in Worplesdon became part of Guildford College in 2003, followed by Farnham College in 2007.

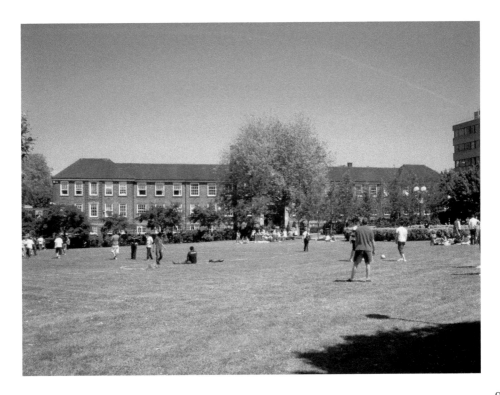

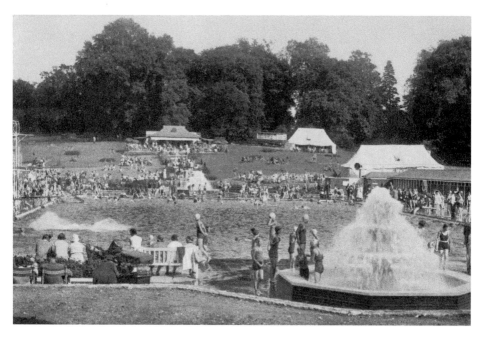

The Lido

Opened at a cost of £13,700 in 1933, the Lido is still a popular place for swimming and sunbathing — weather permitting. The open-air pool was built largely by unemployed men who had been given jobs funded by Mayor William Harvey's pioneering Work Fund, which was made up of donations from employed local people.

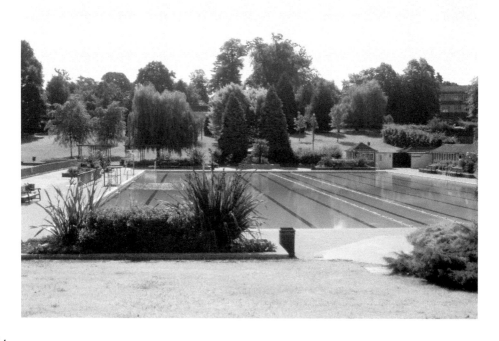

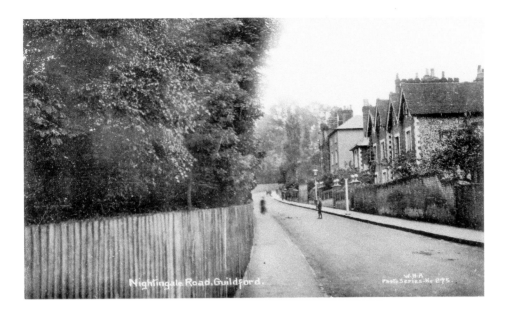

Nightingale Road

In the Edwardian photo a mass of trees and bushes behind the wooden fence screen off the grounds of Stoke Park Mansion, then used as a school. At one time there was a plan to site the technical college here on the corner of Stoke Road and Nightingale Road. Other interesting schemes that were later quietly dropped included a plan to build homes on large parts of Stoke Park. Those who live in the houses here today still have attractive views across the much-appreciated open space.

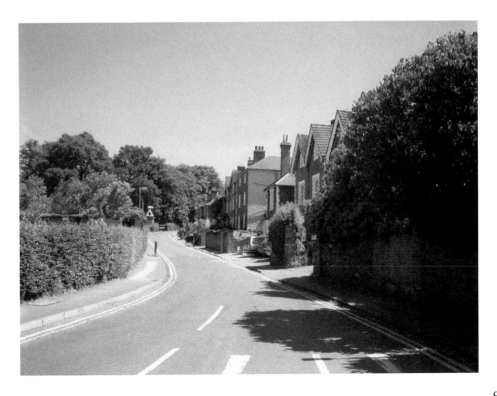

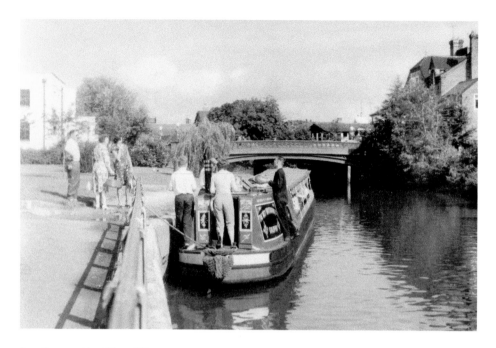

Boating on the River Wey

Back in the 1960s there were certainly not as many narrow boats cruising the River Wey for pleasure as there are today. But the boat here appears to be just that, and not used in the traditional sense for transporting cargo. It is painted with classic pictures of castles and roses, an art form synonymous with boats on Britain's inland waterways. The willow trees by the towpath have now reached maturity.

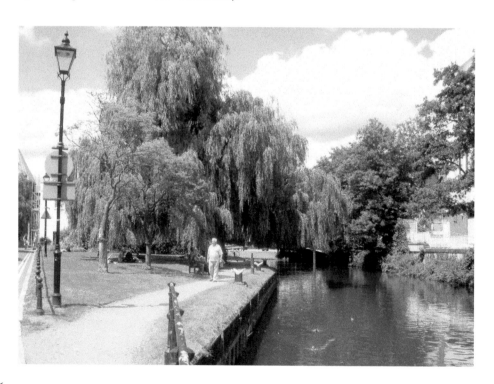

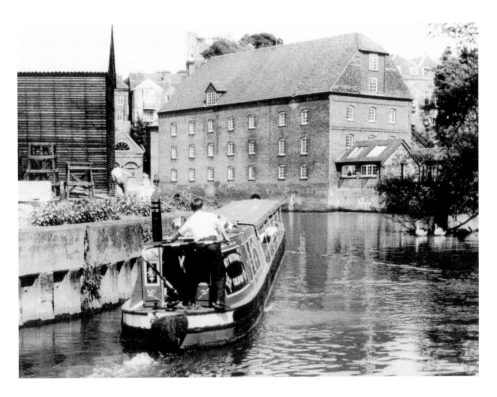

The Town Mill

The same narrow boat is being guided towards the Town Mill, perhaps being turned around. On the left was once Moon's timber yard. The Debenhams department store (opened in 1963) stands on the site now. The mill ceased to grind corn in 1894 when it became a waterworks. Today it is an annexe to the Yvonne Arnaud Theatre.

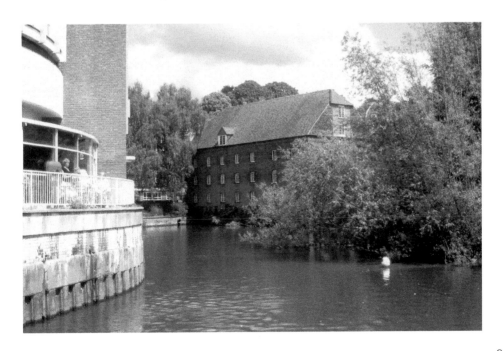

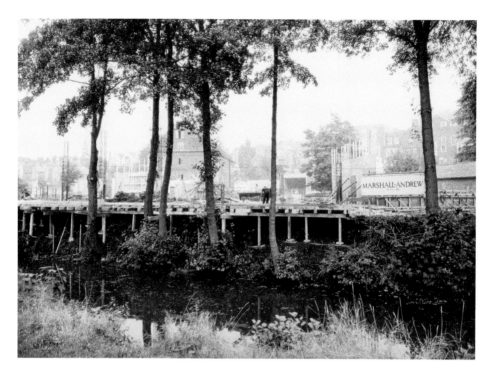

Site of the Yvonne Arnaud Theatre

The foundations have been laid and construction work is starting on the Yvonne Arnaud Theatre. There had once been a foundry on this site. The theatre opened in 1965 with a gala evening with special guests from the world of drama, including Lord Olivier and Dirk Bogarde. The small narrow boat seen in today's photo has just passed through Millmead Lock.

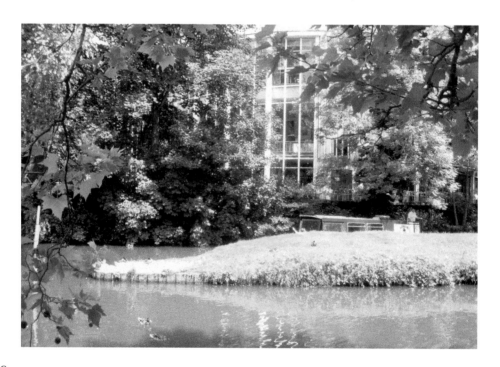

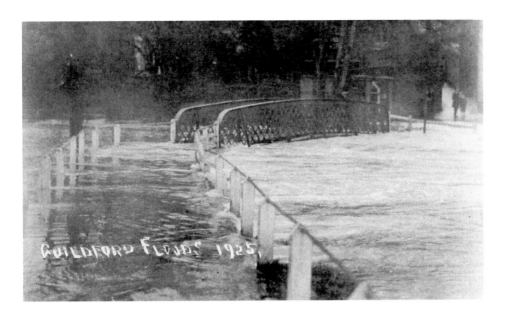

Flooding at Millmead

Anyone who lived in Guildford through the first couple of decades of the twentieth century would have seen the River Wey burst its banks on several occasions, flooding parts of the town. A number of photos were taken of the floods in January 1925 and issued as picture postcards. Here we see the bridge at Millmead. In comparing it to today's photo, the waters then rose to some considerable height — even rushing over the footpath to the bridge.

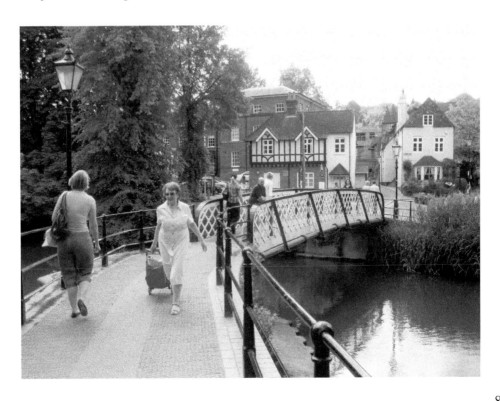

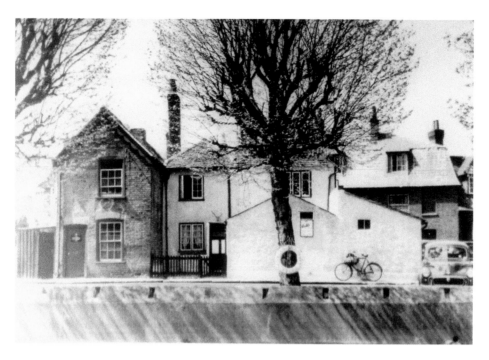

Cottages in Millmead

Seen in about the 1950s is a delightful row of cottages, which at that time included the Millmead Snack Bar. A sign for Wall's ice cream is on the whitewashed wall to the right of the tree. Today, with the seats placed here, it's a popular spot to sit and watch the activities on the river.

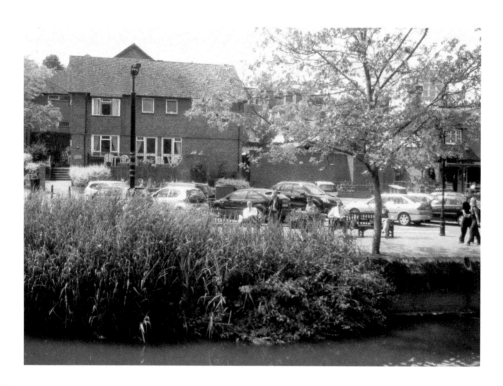

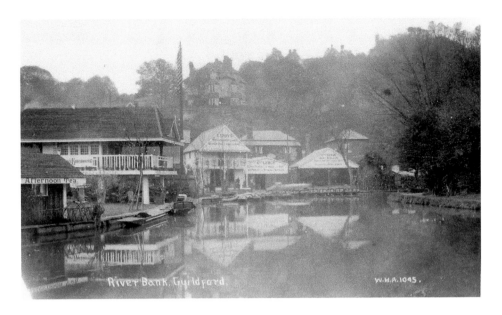

Boathouses beside the River

Our Guildford forebears certainly enjoyed leisure pursuits that took advantage of this lovely stretch of the river. There were once two boathouses here, Allen's and Leroy's. They hired out all kinds of rowing boats, canoes and punts, while also offering teas and refreshments. The old picture postcard view shows the earlier Jolly Farmer pub. Therefore, it must date prior to 1913, when the present pub was built. It is now called the Weyside. Nevertheless, it is still a very popular spot.

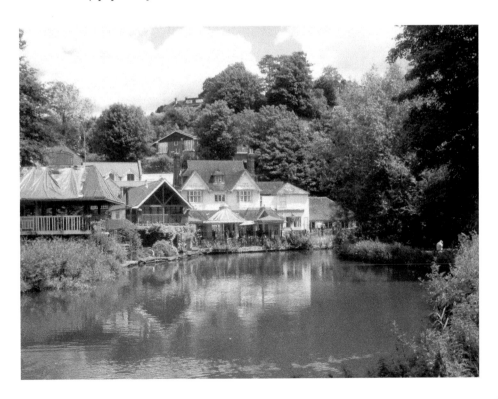

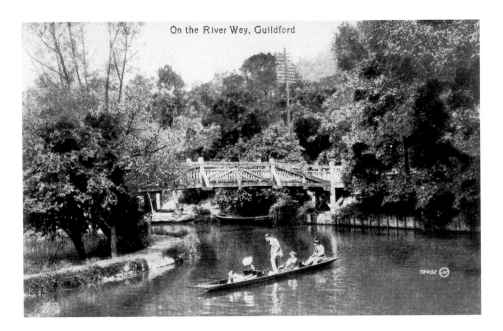

Footbridge across the River

The man standing up in the punt seems to be pushing his luck a bit! But it looks a glorious day to have been out on the water. The view also shows a wooden footbridge linking Shalford Road with the towpath. The bridge that stands today was opened in 1934, replacing the earlier one that had rotted away. Guildford Rowing Club is based on the site where today's photo was taken. Many years ago concert parties, in the style of end-of-the-pier shows, were held here inside a building called the Paddock Gardens.

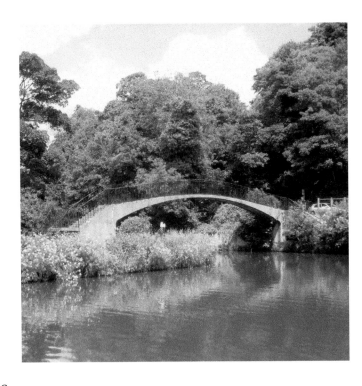

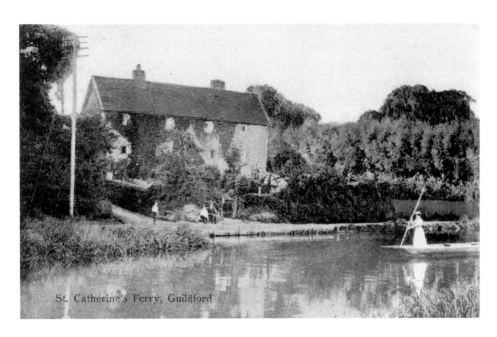

St. Catherine's Ferry, Guildford

St Catherine's River Crossing

Boaters going upstream soon reach St Catherine's. There was once a ferry service here, but by the 1960s it had ceased to operate. Just out of view to the left is a footbridge, opened in 1985, much used by walkers on the North Downs Way. Perhaps more than any other part of Guildford, views around here have become obscured by the unchecked growth of trees and bushes. The evidence can clearly be seen in these two pictures.

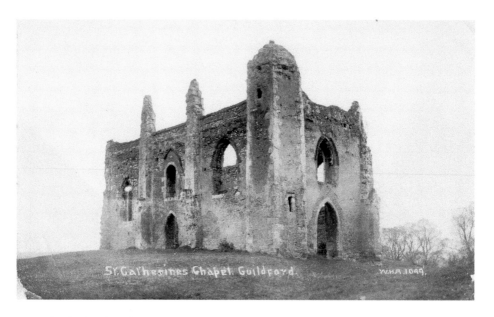

St Catherine's Chapel (Guildford)

St Catherine's Chapel

The ruined chapel can be dated back to the thirteenth century when it is likely to have been visited by pilgrims making their way to Canterbury. The hill has attracted visitors for centuries and an annual fair was held here until 1914. The fence around the chapel today affords some protection from people entering this ancient building and causing any further damage. It stands on a hill of golden sand that continues under the river. The 'golden ford', as it was once known, has given our town its name.

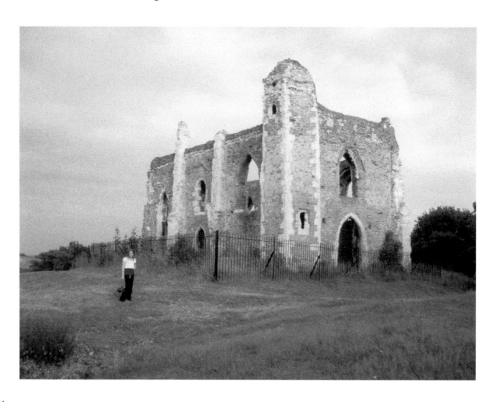

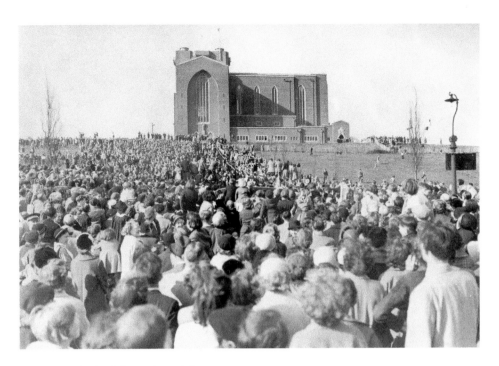

The Cathedral of the Holy Spirit

In 1927, the new diocese of Guildford was created and plans were soon put in place for a cathedral to be built in the town. A perfect site on top of Stag Hill was made available and in 1936 work on the Anglican Cathedral of the Holy Spirit, to the design of Sir Edward Maufe, began. Construction was, in the main, halted during the Second World War but was resumed in the 1950s along with a number of fund-raising campaigns and events. Here we see an Easter pilgrimage in 1955. Whether you like the design or loath it, and opinions are still very much divided among local people, this southern side of the cathedral is today very much in keeping with the vision of a 'jewel in an emerald sea'.

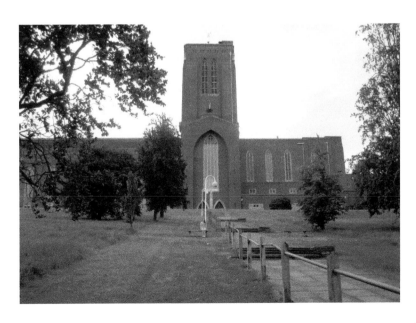

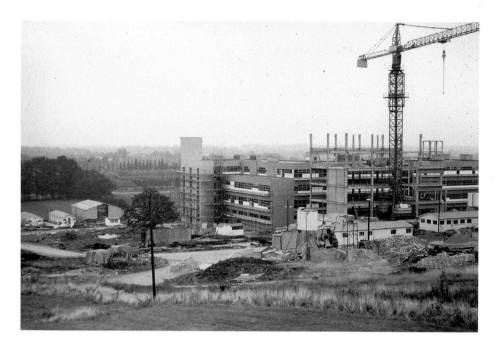

The University of Surrey
In the 1960s, land on the north side of the cathedral was made available for the creation of the University of Surrey. Its royal charter was granted on 9 September 1966, and the move to Guildford by Battersea Polytechnic was completed by 1970. Over the past forty years the university has grown considerably, swallowing up much of the land it was given.

Acknowledgements

The majority of the old pictures in this book are long out of print postcard views in David Rose's collection. Over the years he has also added many more photographs to his collection, copying originals kindly loaned to him by many people. Some of those whose pictures are featured here include Richard Halton, Mrs Grover, the late Mr F. C. Saunders, Vera Wilkinson, John Corpus, Ann Tizard and Geoffrey Melling. Grateful thanks to them all and sincere apologies to anyone not mentioned whose photos have been included.

The authors took the 'today' photos during the late spring and summer of 2009 on digital cameras.

David and Bernard would like to thank their long-suffering wives and families for the time they are graciously allowed to spend perusing their passion for the local history of the borough of Guildford.